SECRET
BEXHILL-ON-SEA

Alan Starr

AMBERLEY

Acknowledgements

Special thanks to Dorothy Smith of the Bexhill Old Town Preservation Society and to the local historian Dave Hatherell. Thanks also to Peter Boyden, Geoffrey Dudman, Lynn Gausden, Eileen Grueger, Sally Ann Lycett, Alex Markwick and his Bexhill Open Street Map, Raouf and Vivian Oderuth, Julian Porter of the Bexhill Museum, David Tye and Jennie Starr.

First published 2019

Amberley Publishing
The Hill, Stroud
Gloucestershire, GL5 4EP

www.amberley-books.com

ISBN 978 1 4456 5458 4 (print)
ISBN 978 1 4456 5459 1 (ebook)

British Library Cataloguing in Publication Data.
A catalogue record for this book is available from the British Library.

Origination by Amberley Publishing.
Printed in Great Britain.

Contents

Introduction

Bexhill is well served for history books and websites, and there are frequent walking tours through the town for interested visitors. There is still a thriving local museum. Most of Bexhill's development happened after the invention of the camera, so there are many photographic histories of the town.

It is hard to think that the town could have any secrets left, yet it is full of surprises. In Dorset Road young Nazi maidens celebrated the Fuhrer's birthday. In Newlands Avenue Britain's foremost modern dramatist, David Hare, suffered the torments of a suburban childhood. In the old manor house, the 8th Earl De La Warr employed an electrical inventor best known for marketing a death-ray machine.

Bexhill-on-Sea has a reputation for conservatism and retirement. Spike Milligan described it as the only cemetery above ground. Yet the Old Town, the seafront and the residential acres between have been home to some quite extraordinary people.

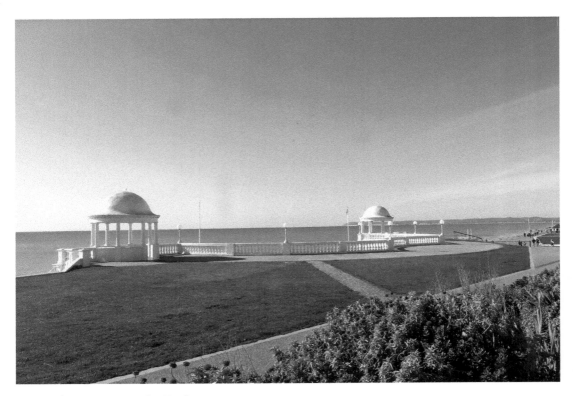

Looking west to Beachy Head.

1. Early Days

There have been people visiting Bexhill for at least 10,000 years. A single vegetable patch in Terminus Road has produced evidence from the Mesolithic period to the Bronze Age.

The recorded history begins in AD 772, when King Offa defeated the men of Hastings and granted some of their land – at a place called 'Bexlei' – to the Church. This is why the A259 becomes King Offa Way as it slices through northern Bexhill. Parts of an Anglo-Saxon church are now hidden in the walls of St Peter's. In 1066 William the Conqueror landed at nearby Pevensey. After landing, William moved towards Battle and devastated the few farms that existed at Bexhill. It had not fully recovered by the time of the Domesday Book in 1086.

In 1570 the manor of Bexhill was given to the Sackville family, a family still remembered in the name of Sackville Road. In 1597 a Dr Thomas Pie repaired the church's Chantry Chapel and turned it into a schoolhouse. It is probably the first school in a town that has been home to hundreds.

Galley Hill, looking east towards Hastings.

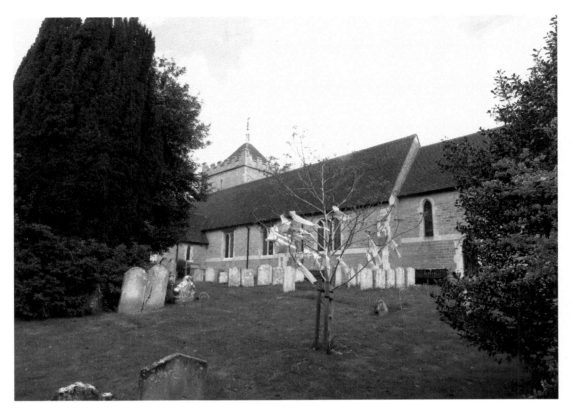

St Peter's Church.

We know that he had 225 churchgoers. Leaving his schoolhouse, Dr Pie would have seen before him a 100-year-old great walnut tree. In 1890 it was still there, and the locals were campaigning to keep it as it was threatened by road widening. The walnut tree – surely the oldest resident in the town – was cut back and then finally succumbed to the great storm of 1921.

The Old Town in Bexhill still survives and gives a hint of what the area might have been like in the days before the seaside development, the railway and the A259. Bexhill, like its neighbours Eastbourne, Pevensey and Brighton, was for most of its existence a small hamlet on a hill, a mile from the sea. Placing buildings by the sea would have been a risky business. The coast could be attacked by storms or pirates, and Bexhill was damaged by great storms in 1250 and 1729. Only the cult of sea bathing made people wish to visit the coast. Long after Brighton had become a watering place, Bexhill stayed in its hilltop.

If we look at the Old Town and the roads leading away from it – Chantry Lane heading north or Sea Road heading south – we can see a continuity from earlier times to the modern day. There was a time only a few lifetimes ago when 'Bexhill was a tiny village crowded between the venerable church and ancient manor house. Between it and St Leonards there were scarce half a dozen houses.'[1]

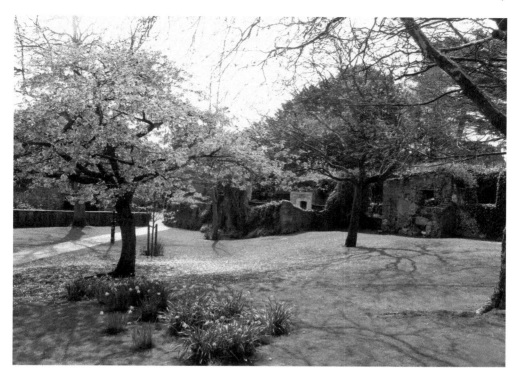

The Manor Garden.

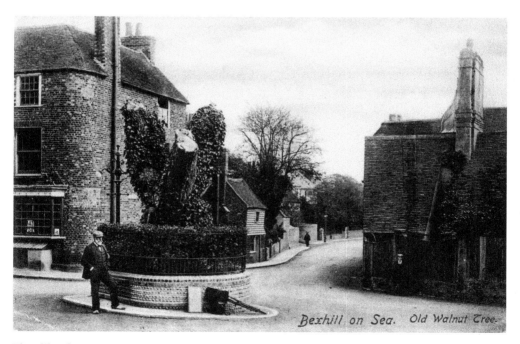

The old walnut tree.

2. Napoleon and the Hanoverians

The Hanoverians Arrive in Bexhill

In 1803, 13,000 soldiers of the French army moved into Hanover, meeting almost no resistance. Once established there, the French began to chop down the giant oak trees in the German forests. The timber was moved down towards the Channel, to be turned into flat-bottomed invasion barges for use by Napoleon's invasion force, his 'Army of England'. This had a profound impact on Bexhill.

The British royal family at this point was the House of Hanover. George III, as well as ruling the United Kingdom, was the head of state – the Elector – of Hanover. When Hanover fell to the French, the Duke of York had agreed to bring 4,000 soldiers over from the conquered territory. The work was delegated to Major Drecken, who was given the rank of colonel and offered fifteen guineas for each man he recruited. Over time, a total of 28,000 men served in the new formation, which became known as the King's German Legion or KGL. The obvious place to locate soldiers was close to the Channel, ready to meet the invader. The first barracks for the KGL infantry was at Bexhill.

The Barracks

There had been a military camp in Bexhill since 1790, just west of the Old Town. It seems to have been a neat affair. In 1798 an American visitor travelled along the road from Little Common to Bexhill and saw, to his right, a barracks for 1,000 men. It consisted of wooden buildings with red tiled roofs. The new barracks began life as a more chaotic affair.

The KGL, when it arrived in 1804, needed new accommodation very quickly. To begin with, the German troops had to build primitive huts of earth, with thatched roofs. A local landowner happily provided the thatch. Christian Ompteda, an officer of the KGL, reports in his letters that on 11 October 1804 the men began to build, but on 27 October the camp was flooded and the hut building had to stop. One visitor describes these 'turf cantonments' built by the soldiers: 'The barracks are placed in the worst possible situation, a drain frequently almost sufficient to poison the whole place runs under it, and the necessary-houses are so arranged as to make many of the rooms scarcely bearable in hot weather.'[1] The camp turned into a swamp and to make matters worse, the locals made an indescribable noise on the evening of 5 November, celebrating Guy Fawkes Night. For the new arrivals it was a wretched experience. As a senior officer, Ompteda could visit the local population and enjoy their civilised houses. He mentions a Miss Mary Lansdale, who was no more than a peasant but was very neatly dressed. In 1805 the mess house was completed, and life began to get better According to Ompteda, the local population regarded the new arrivals in the same fearful way that the Germans regarded the Cossacks. When he visited the local gentry, however, local opinion softened.

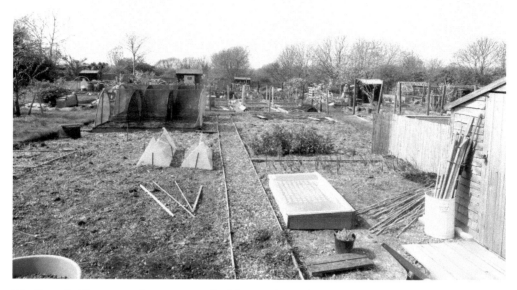

The Barrack Allotments, the western end of the KGL barrack ground.

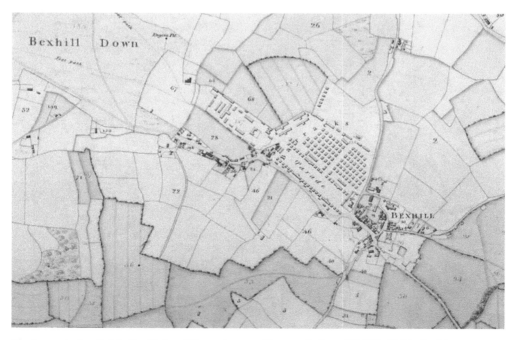

The barracks in 1806 in the Duke of Dorset's map. (By permission of ESRO, AMS 5819/1)

Bexhill prospered, developing from a small hamlet to a small market town. The local girls responded, inevitably, to the presence of a whole camp full of soldiers. There were many recorded cases of German soldiers marrying local girls (or failing to marry them). The newcomers were, of course, glamorous. Over in Dorset, Thomas Hardy recorded that the cavalry of the KGL with 'their brilliant uniform, their splendid horses, and above all, their foreign air and mustachios (rare appendages then), drew crowds of admirers of both sexes wherever they went'.[2]

In Bexhill we can trace the brief marriage of one local girl, Mary Ann Pumphrey. Her father was Thomas Pumphrey, a riding officer for the Port of Rye who was stationed in Bexhill. As a riding officer, he was given a horse, a cutlass and a pair of pistols. His job was to ride around the area spotting signs of smuggling. His daughter Mary Anne married Captain Philip Holtzermann in 1812. She was widowed on 18 June 1815 when Captain Holtzerman died at Waterloo. Mary Anne was living in Hanover in 1815, and remarried there.

Things were not so straightforward for Sophia Brazier, a local girl who became pregnant when she was just sixteen. In April 1813 Sophia said that the father was Captain Frederick Rehwinckell of the KGL artillery. He denied that he was the father and blamed Sophia's 'bad and wicked purpose' for the claim against him. 'That lewd girl', as he called her, had her son Victor baptised in May 1813.

The KGL barrack ground, now a playground.

The Pumphreys' houses in the Old Town.

The distrust of the Germans ran deep. Major Ompteda was aware Germans might not be welcome, partly because the monarch was so fond of them: 'Even the German tune "Landesvater" is said at time to have taken precedence over "God Save the King."'3 English radical William Cobbett was always keen to spot signs of disloyalty among these foreign troops. In October 1810, for example, five members of the KGL had stolen a boat on the beach at Bexhill, and had headed back to the Continent, never to be seen again. Many of the KGL had in fact been in the French forces and had deserted in order to join the British. Anti-German feelings came to a head in 1809 when the local militia in Ely protested about stoppages in their pay. The Kings German Legion was called in and the five ringleaders of the protest were sentenced to 500 lashes each. Cobbett objected to this: 'the flogging of Englishmen, in the heart of England, under the superintendence of hired German troops, brought into this country to keep the people in awe.'4 For his trouble he was sentenced to two years in Newgate prison and a fine of £3,000.

In 1812, sitting in Lord Ashburnham's parkland a few miles away, Mary Anne Gilbert of Eastbourne portrayed a very tidy Bexhill barrack square. The Germans were now accepted, and the camp was a place of decorous military drills.

> Here faithfully guard the forward post
> Of Britain's vulnerable coast
> No longer a distrusted host.
>
> …

We almost see them there arrayed
And marshalled on their gay parade;
Now wheeling, show alternate flanks,
Now close, in form compact, their ranks,
And all along the redcoat line
Their polished arms, quick-glancing shine.5

The Drunken Parson

'At Bexhill barracks, some years ago, there lived a jolly parson, who frequently dined at the mess then quartered there.' This is the start of a story by John Shipp, an officer of the 87th Foot who was stationed at Bexhill in 1806. The parson, we are told, had many bad habits, not least a liking for very short sermons and very long drinking sessions. The commanding officer came into the mess late one night to find the parson incapacitated, being held upright by some of the young officers. He decided to teach the parson a lesson.

Quite who the parson was, we cannot be sure. The records in St Peter's Church tell us that at this time the vicar of St Peter's was George Pelham, a member of the very influential Lewes family. Bexhill had a public house called the Pelham Arms, and the Pelham buckle decorates many Sussex buildings. George Pelham became vicar in 1792 but moved on in 1803, and soon became the Bishop of Lincoln He retained his role as vicar

The graveyard at St Peter's.

of St Peter's – and the £200 annual salary – for the rest of his life. His total income at his death was over £8,000 p.a. from his different clerical posts. Bishop George Pelham died, oddly enough, after catching a chill at the funeral of the Duke of York, the very man who had first established the German Legion.

<div style="background:#ccc">

DID YOU KNOW?
At the barracks in 1802 a soldier of the 9th Infantry was found to have robbed one of his officers. He had been living with the officer as a servant. Under arrest, the soldier killed himself. His body was taken to local cross-roads and buried with a stake through the heart.

</div>

In George Pelham's absence, the church was run by a curate called Edward Wareforde, perhaps he was the man who was found drunk in the officers' mess that night. The commanding officer ordered that the drunken clergyman be taken to the barrack hospital and put to bed in army nightclothes. His leg was put in a splint and bandages. When the parson awoke the next morning, he found the colonel and the surgeon in attendance, concerned about his inflamed leg. The surgeon called for six grenadiers to hold him down while the leg was amputated. The splints and bandages were removed and 'lo! the parson's broken leg soon bore him on swift wings of speed to his home and he was never seen after in the barrack square of Bexhill.'[6]

La Haye Sainte
The KGL provided troops for the British army in its Peninsula and northern European campaigns. In some cases, they did prove liable to desert, as Cobden expected. For the most part, however, they were valued soldiers. There is a memorial to the KGL at the battlefield of Waterloo.

During the evening of 17 June 1815, Wellington positioned his forces on the battlefield of Waterloo. The bulk of his allied army – of which only a third was British – was on or behind the east–west ridge, blocking the road to Brussels. In front of this ridge were some farmhouses, which could be turned into makeshift forts, acting as breakwaters when the French waves advanced. One farmhouse, La Haye Sainte, was to be manned by the 2nd Light Infantry Battalion of the KGL. The battalion arrived with its commander Major Baring at 19.30, and set about fortifying the building in steady rain. They had only a few tools left around in the farmyard, and someone had unfortunately removed the main barn door, presumably to light a fire.

There were only 400 men and, to make matters even more difficult, they had only sixty rounds each. Some of the regiment's ammunition had been lost the day before, when a wagon overturned during their retreat. Even worse, the KGL were using the Baker rifle, which required its own special ammunition. At 14.00 on the 18th, the French attacked La Haye Sainte in their thousands. In the melee, a single bullet from the KGL might pass

Rear view of the 'Barrack Hall'.

through three attackers. Soon the mound of French dead formed an additional defensive wall for the farmhouse. Baring received some reinforcements from other KGL units, including the 1st Light Battalion. This battalion included Captain Holtzerman, who had married Anne Pumphrey in Bexhill on 12 January 1812. At 15.00 Marshall Ney ordered an attack on the farmhouse. Again, it was unsuccessful, and again Baring sent a request for ammunition. As the afternoon progressed, the French attempted to burn the farmhouse down. The defenders tried to dowse the flames using their kettles. Baring received more reinforcements, but the French eventually captured the farm.

Colonel Ompteda, who had built the first barracks in Bexhill, was instructed to recapture the buildings using the 5th Line Battalion of the KGL. He at first refused to obey because the French cavalry was present, but he was told he had to move in. He ensured that his son was sent to a safe place, then led his men to La Haye Sainte and certain death; the French cavalry cut them to pieces. Ompteda was last seen on his horse in the kitchen garden, surrounded by French infantrymen. He died from a bullet in his neck. With la Haye Saint captured, by 18.00 Wellington's centre was close to collapse. This was what the KGL had managed to prevent through the whole day of the battle. Fortunately, another set of Germans, Blücher's Prussian army, started to arrive on the British left flank, freeing up men to reinforce the centre. Wellington famously said that the battle of Waterloo was won on the playing fields of Eton. We might make the case that the battle for La Haye Sainte was decided on the barrack ground of Bexhill.

The Memorial Ground.

The KGL is still remembered in Bexhill, but physical remains are not plentiful. The local allotments are still called the Barrack Allotments. There is an assumption that the building called the Barrack Hall, in such proximity to the Barrack ground, must have been used by the military. There was a story that the Duke of Wellington tethered his horse here when he was inspecting the troops. The memorial garden did once have the gravestones of many KGL soldiers, but these were disturbed by a bombing attack in the Second World War. At one time a metal sign was erected here, but it has since been damaged by a storm. None of the remaining gravestones commemorate a KGL soldier.

The Martello Towers
By 1804, there had been a general threat of a French invasion for many years, but the thought of Emperor Napoleon seems to have woken the British government. In the case of Bexhill this meant the building of twelve Martello towers along the shoreline. The towers were round squat gun platforms, with living quarters inside for twenty-four (presumably small) men. For the government, they offered a powerful chain of artillery platforms to prevent a landing on the south coast. Not all senior soldiers agreed with this assessment. The Duke of Wellington expressed a view later that these towers were really no more than sentry boxes.

One account tells us that the KGL ripped walls away from the Old Town and transported the bricks down to the beach to make the towers. This would not have been a sensible way to progress. Each tower used a quarter of million bricks, and we are told that

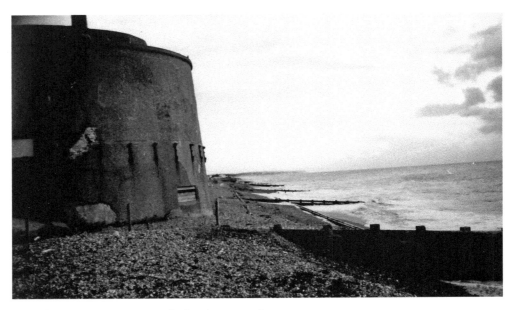

Martello tower at Normans Bay before its restoration.

four brickyards were established in Bexhill. Others say that bricks arrived from Rye by barge. Most Martello towers were in fact constructed from good-quality London bricks. The government had hoped to use local bricks made from the Wealden clay beds, but in practice the work was contracted to Messrs Adam and Robertson of Old Bond Street, with an initial order for 10 million bricks in 1804. These brokers made a profit of 3s 6d for each thousand bricks. A Mr Hobson was contracted to build the towers on land purchased by the government from private landowners. Mr Hobson subcontracted the work to Mr Smith and Mr Hodges, and all three of them became rich. We know that Tower 42 at Bulverhythe was on a leased plot, with the owner promised £7 a year until 1904.

In all, seventy-four towers were built on the south and eastern coasts of England. Engineer officers carried out an inspection in May 1808 to help settle Mr Hobson's bill. They found that most of the building work had been finished, but in many cases, guns had not been fitted. Some of the Martello towers never did have guns, and even if they had been properly equipped, there was a problem with finding suitable soldiers to man them. Artillery officers and trained gunners were a scarce resource. The government never decided how to deal with the problem: at one point it had the idea of using invalided artillerymen. By the time the Martello towers were completed – before many of them were even started – the threat of invasion had been lifted and the question could safely be left unanswered. They were often regarded with suspicion: there were claims that could not fire at target closer than 1 mile; that they should have had two guns but could support only one; and that they were so unstable that the gunners were afraid to fire.

As gun platforms, they were never called upon to resist a French invasion, and were probably built too late to deter one. However, as military blockhouses all along the coast of Sussex, they would soon prove very useful in the war against the smugglers.

3. The Bexhill Coalfield

The barracks and Martello towers in Bexhill meant that wells had to be dug. Looking down into one of these wells, local man Josias Routledge was convinced that he could see a seam of coal. At this point, in the summer of 1805, the search for the Bexhill coalfield had begun. There was a special reason why this part of Sussex wanted coal. The Sussex iron industry was close to its end in large part because the industry had to use charcoal. One of the last ironmasters, 'Mad' Jack Fuller of Brightling, was sure that he had found coal on his estate, and wanted to take samples to the Royal Institution. He was unfortunately mistaken: what he had found was little more than some very old wood.[1]

Even without an iron industry, coal could be a very attractive proposition for a landowner. Arabella Diana, the Dowager Duchess of Dorset, had a decent income of £13,000 per annum and owned much of the land around Bexhill; she was happy to become richer still. A surveyor was soon on the case: William James (1771–1837), a railway and tramway pioneer. He had begun life as a land agent, encouraging owners to exploit the mineral wealth on their estates. He was a successful owner of a coalfield, and from this began his later interest in railways. He was man with great visions and enthusiasm, who went bankrupt in 1823.

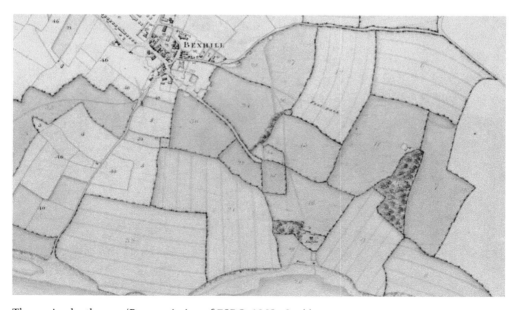

The engine by the sea. (By permission of ESRO, AMS 5819/1)

In October 1805 James began to conduct a survey of the whole area to determine whether a coalfield was geologically possible. After a great deal of research, he was able to conclude that the area might very well support a coal mine and he proposed three sites for exploration, two by the beach and one on Bexhill Down, near the barrack field. These findings were reported to the duchess, and a syndicate was formed. The partners included the duchess, her husband – Charles Whitworth, lately ambassador to Napoleon – and Nicholas Vansittart, soon to be the Chancellor of the Exchequer. The syndicate also included Josias Routledge of Bexhill. The mining required an Act of Parliament, which was obtained by the intervention of the Sussex MPs, including Jack Fuller.

The newspapers for 1806 reported hundreds of miners busily at work. In June of that year the owners were so optimistic that they were preparing to raise the coal immediately. At the first site, close to the modern-day Ashdown Road, there was a steam engine. This may account for the appearance of Matthew Boulton in Bexhill. Boulton was James Watt's business partner and installed steam engines up and down the country. To the north, the Bexhill Down site may have had only a horse-drawn engine, pulling buckets up from the shaft.

DID YOU KNOW?
The geology of the area has led to significant fossil finds. Dinosaur footprints have shown up on the beach, and in 2018 a fossil hunter found a small rock that turned out, on closer inspection to be the brain of an iguanodon.

The site of the engine pit at Bexhill Down.

There was an ominous report in the press in July 1807: the miners had come across a stratum of earth containing a great deal of salt. This, it seems, tasted very salty, and even if the salt could not be extracted, the earth might prove very saleable as manure.[2] This was not what the investors had in mind.

Just how much the syndicate lost is not clear. The enterprise finally ended in 1811, with no coal raised or sold. At the time, costs of £70,000 and £80,000 were mentioned for the whole enterprise, each participant bearing his or her proportion of the loss. Josias Routledge suffered especially in this venture. In 1803 he was happily living as a gentleman with substantial holdings in Bexhill, had a vast an imposing house called Millfields and had wisely invested in British government bonds. A few years later he was selling off some of his property to finance the mining venture. In 1822, he was communicating from Dieppe, a traditional bolthole for English bankrupts.

Perhaps more galling for the syndicate, the Bexhill Coalfield achieved some notoriety as an example of poor science: 'Some years ago, ignorant people persuaded the Duchess of Dorset to expend about £10,000 in vainly searching for coal at Bexhill, in Sussex: where any geologist (as now instructed) could at once have pronounced that none would be found.'[3]

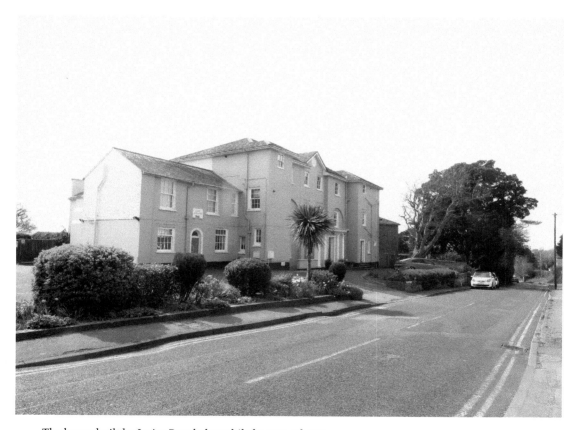

The house built by Josias Routledge while he was solvent.

4. The Smuggling Trade

When the Napoleonic wars ended, said J. P. Wills, Bexhill's first historian, the vestiges of the coal mine almost vanished. There was one 'long quaint house' made up of the offices and stables of the coal company. The drill ground was ploughed over. The town was larger than it had been, and must have looked in many ways as the old town does now. The old lanes are now roads but retain their old character.

The local population 'settled down again into its farming and smuggling'.[1] This latter activity was soon to become difficult.

Smuggling had been a part of the local economy for centuries. As late as the 1820s, along the coast in Pevensey, officers of the Coastal Blockade had apprehended Thomas Maynard bringing brandy ashore. The local magistrates were called out to hold a trial, and were baffled by the fuss. Surely, they said, a local lad was not going to be sent to prison just for bringing a few tubs ashore, especially with Christmas coming. The accused was put into a rickety shed from which, with no great bother, he was able to abscond within a few hours. It was even said that some riding officers were easy-going men who avoided trouble and were happy to receive the occasional cask of brandy.

The Forge.

46696. BEXHILL-ON-SEA: UPPER SEA ROAD.

Above: Sea Road.

Right: Chantry Lane.

BODOM & HAWLEY, BEXHILL.

It would sometimes have been unwise for the riding officers or the colleagues the customs officers, to fight off the smugglers. The numbers were against them. In July 1797, for example, Thomas Pumphrey, a riding officer in Bexhill (the one whose daughter Mary Ann married a KGL captain), found contraband buried in the local beach. There were six casks (21 gallons) of gin, six casks of rum and four casks of brandy. He was only able to recover one cask of brandy: the rest were seized by local smugglers William Miller and Plummer Beechin, along with 150 other men.[2]

During the Napoleonic Wars, the Sussex smugglers kept to their old trade. For obvious reasons, this kind of criminal and treasonous activity was rarely documented, but we know that Napoleon created a 'City of Smugglers' in Dunkirk, where up to 500 British smugglers might be resident at any one time. They engaged in the traditional deliveries of French brandy, but in return brought back an astonishing variety of goods. A rich French family wishing to release their officer son from an English prison could go to Dunkirk and pay the appropriate fee. The smugglers delivered letters of credit and sometimes they even transported gold over to France. The French financial system was not adequate for Napoleon and throughout his career he relied upon the City of London. Importantly for Napoleon – who never believed his own generals – the Sussex smugglers also brought newspapers:

'It is on record that all through the last war with France the daily newspapers and correspondence were regularly carried to Napoleon by a family then resident in Bexhill, Sussex.'[3] That is from a nineteenth-century book on smuggling by the appropriately named Mr Shore.

DID YOU KNOW?
John Wesley's Methodism had followers in Rye, but a large tract of southern Sussex was a 'Methodist Wilderness'. In 1809 there were twenty-three followers in Bexhill, perhaps because the barracks housed soldiers from the north of England. When Methodists tried to preach on the beach at Hastings they were stoned. The problem was smuggling, which Wesley hated. Only after the introduction of the Coastguard was Sussex safe for Methodists.

By the end of the Napoleonic Wars, the government in London had decided to do something about smuggling. The government was debt-ridden and had been obliged to increase customs duties – the Chancellor of the Exchequer was the same Nicholas Vansittart who had invested foolishly in the Bexhill Coalfield and was now entrusted with the nation's finances. The war on smuggling was not simply a financial matter. The large numbers of smugglers and their brazen behaviour meant that the authorities felt obliged to assert themselves.

Even during the war, Lord Castlereagh had made it plain that the Martello towers were to be used against smugglers. In the immediate post-war period, there was plenty

of military and naval surplus to be employed. Two royal naval vessels were anchored at the Downs (off the coast of Kent) and at Newhaven. These ships were dedicated to the new Coastal Blockade, and naval personnel were housed in the Martello towers. These land-based sailors were commanded by naval lieutenants who presumably would have preferred to be at sea, but in the post-war period their career options were limited.

J. M. W. Turner's picture of the Martello towers somewhere near Bexhill has some enigmatic figures in the foreground. There is a man with a stick urging a laden donkey, and there are two cavalrymen, possibly hussars, racing towards us. There are also broken boats on the beach. It is not clear what the narrative is, but this is obviously a story about smuggling.

The government devoted its resources to stopping smuggling. As the government's grip tightened, the conflict became more violent. At Little Common in 1822, a watchman at Little Common was attacked with a 'bat' – a 6-foot ash pole expressly designed for hitting people. In Bexhill in September 1824, seven smugglers attempted to land with 100 tubs of spirits. A blockade man called Welch jumped into the boat. The boat pulled off from the beach and Welch's battered body was found the next morning. It was said that Welch invited this treatment because he had previously taken a bribe from the Little Common Gang, promising to turn a blind eye.

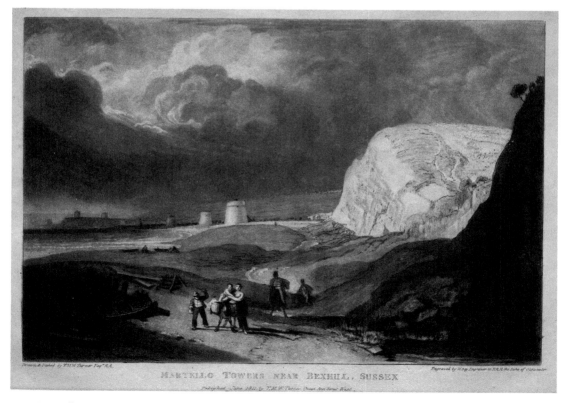

Martello Towers near Bexhill by J. M. W. Turner.

Little Common, home of the Little Common smuggling gang.

The most extreme violence was in 1828 when a lugger landed at the coast between Bexhill and Hastings. The large cargo was landed and transported – by horse, cart and on foot – to Sidley Green. The blockade men responded in serious numbers: forty of them, fully armed, led by a Lieutenant Taylor, attacked the smugglers. The smugglers – perhaps containing ex-military men – formed themselves into a regular line and fought back with their 'bats'. By the end of affray – 'The Battle of Sidley Green' – many of the blockade men were injured and their Quartermaster Collins was dead. The blockade men had used firearms and one of the smugglers, an old man called Smithurst, was killed. Very little of the contraband was recovered by the blockade men but several of the smugglers were caught and were tried at a mass trial at the Old Bailey. The trial was of the men at Sidley Green and also a group accused of similar offences at Eastbourne. Among this latter group was Thomas Maynard, who had been so leniently treated in Pevensey a few years earlier. This time Maynard and the other smugglers were lucky to be deported to Australia.

In 1831 the Coastal Blockade was absorbed into the new Coastguard service, and the Sussex coast – for the first time in its history – was controlled by London. In 1837, the government received a report on the 'Disturbed Districts of Sussex'. Smuggling had been suppressed, and the effect was grim for the local economy. According to the Poor Law

Sidley Green site.

Commissioners, it had led to an increase in the poor rate. The labourers of Bexhill used to have plenty of work in the summer and could resort to smuggling in the winter. In short, the Commissioners conclude, 'the putting down [of] smuggling is the ruin of the coast.' It was not only the poor who were suffering: 'Large capitals have been invested in this business, particularly in Bexhill. Many of the small farmers, if they do not participate, certainly connive at these practices.'[4] A good example of this was the Little Common Gang, led by the Gilham family of Peach Cottage. By day they were respectable carpenters and builders, and at night they diversified into smuggling. Interestingly, the Gillhams did in fact keep records of their illegal activities; perhaps the sheer scale of their business demanded proper bookkeeping.

In Sussex in 1830 there was a clear overlap between smuggling and the wider society. The smuggling gangs had their own standards: they would never leave a wounded man behind to be arrested, and they had their own hierarchies (the bat-men near the top). The organisation of the smugglers – and especially the use of large gangs – was carried into a wider social disturbance. For example farmers were being intimidated by large groups of farmworkers. In November 1830 a Bexhill farmer called Crowhurst had a lodge on his Bexhill property burned down. Two weeks later his barn and 200 trusses of straw

were burned down. This kind of lawlessness was rarely anarchic: the farmworkers were pressuring the farmers for specific concessions.

Since the start of the Napoleonic Wars, the population of Bexhill had risen steadily. In the 1830s the population registered a small fall as people left for the colonies.

The remains of a Martello tower. (Paul Wright)

5. Building Bexhill-on-Sea

For much of the nineteenth century Bexhill remained a hilltop town. A typical Sussex coastal town – like Pevensey or Eastbourne or Brighton – began with a small settlement on a hill, a mile or two from the coast. In the eighteenth and nineteenth centuries landowners began developing seaside resorts. In Eastbourne the Duke of Devonshire planned the 'Empress of Watering Places'. In the 1870s and 1880s the duke and the Gilbert family – descendants of Mary Ann Gilbert, who wrote poetry about the barracks – executed a grand plan to move the poorer families away from the seafront, clearing the way for luxury hotels. Bexhill was one of the very last towns to aspire to resort status, but the De La Warr family could see rich possibilities. The town was destined to grow. In 1881 there was a population of 2,452, and by 1888 this had reached 4,000. In 1901 it was over 12,000.

Before it could become a coastal resort, Bexhill had to deal with the problem of the coast. The Channel produces some vigorous weather, and Bexhill has experienced a few storms, notably in 1250 and again on 20 May 1729 when a typhoon ripped across the countryside. It has also had a very unstable coastline. In the second half of the nineteenth century, some of the Martello towers on the coast were destroyed deliberately by artillery fire, but most of them were simply reclaimed by the sea.

A first step in creating a seaside resort had to be the creation of sea defences, but this required money. The 7th Earl, Reginal Sackville, obtained a licence in 1882 to build a sea wall between Galley Hill and Sea Lane. He employed a Mr John Webb of South London to do the work. This eastern part of the town was being defended, as it was here that the earl planned to create his new resort. Mr Webb was perhaps a shrewder man than the earl, and he agreed to forego part of his payment for the sea wall in return for a tract of land south of the railway and west of Sea Lane. The total bill for the sea wall was in the region of £40,000 and the De La Warrs did not have the money.

The 7th Earl built the Sackville Hotel and – typically perhaps – made sure that a part of it was his private residence when it opened in 1890. He decided that the development of the resort should be left to his son, Gilbert. Gilbert had limited business experience or sense, but had great enthusiasm.

In 1896 he opened the Kursaal, a pavilion built over the beach. A kursaal was a cultural meeting place, whose German name suggested the spa resorts of Central Europe. In its original design, the Kursaal was to be a majestic domed hall, rather like the Palais de la Jetée in Nice. In practice – and this is typical of Bexhill's grander developments – only the first part was built, projecting across the beach but not really reaching the sea. There were many calls in later years for Bexhill to have a real pier, but this never happened. The Kursaal was a concert hall and a theatre but Gilbert seems to have lost interest and sold the building in 1908.

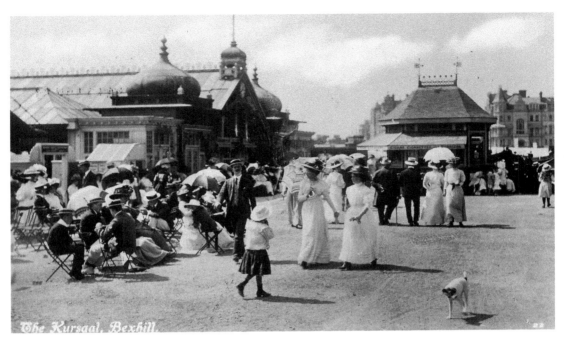

Bexhill as a fashionable resort.

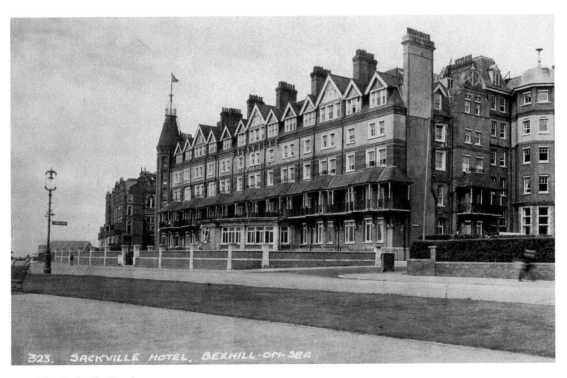

The Sackville Hotel.

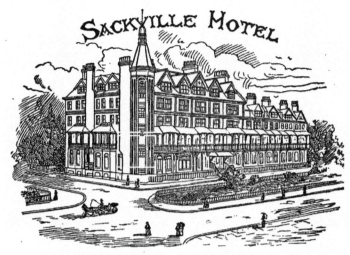

The Sackville Hotel advertisement.

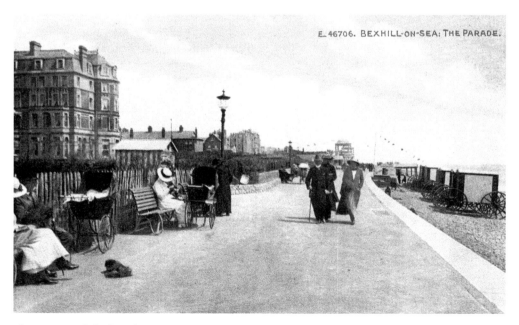

The promenade before the First World War.

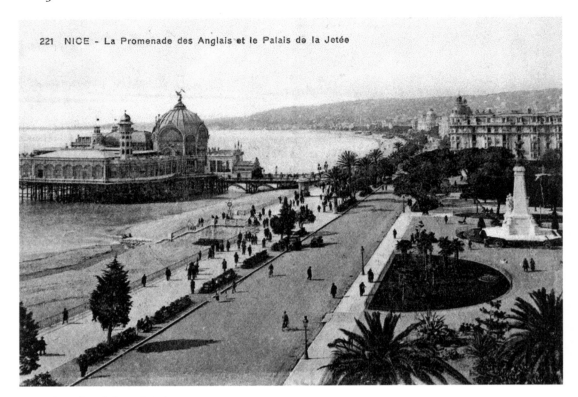

221 NICE — La Promenade des Anglais et le Palais de la Jetée

The Palais de la Jetée, Nice.

The Marina Arcade and Parade

Bexhill-on-Sea

The Kursaal and the promenade.

The Kursaal tea gardens.

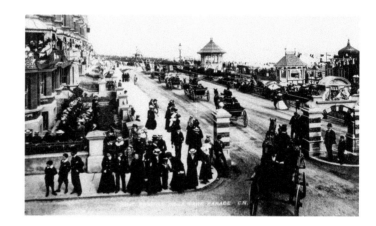

The De La Warr gates. No shops were permitted past this point.

Ashdown Road, the industrial heartland of Bexhill-on-Sea.

East of the Kursaal was De La Warr territory. There were large gates there to prevent undesirables from entering. There were hotels here, but no shops were permitted. The seafront buildings were of an imposing kind. This was to be the heart of the decorous and exclusive resort of Bexhill-on-Sea.

There was one problem. In Ashdown Road – the site, oddly enough, of the steam engine pit for the Bexhill coal mine – were the gasworks. These were built by a company controlled by De La Warr, and the location of the works seems inexplicable. They put a natural limit to the possibilities of eastern Bexhill as a refined resort.

Mr Webb

West of Sea Lane a different Bexhill was emerging. John Webb from South London had built the sea wall successfully and was now creating a solid and elegant middle-class resort in his tract of land. At the heart of this were Egerton Park and the surrounding Egerton Park estate. Mr Webb lived over to the west at Wickham Lodge, Cooden Drive. He was, however, closely concerned with the development of the town for over thirty years. Thanks in large part to Mr Webb's activities, by 1901 the population of the town had risen to 12,000.

Egerton Park and the surrounding estate.

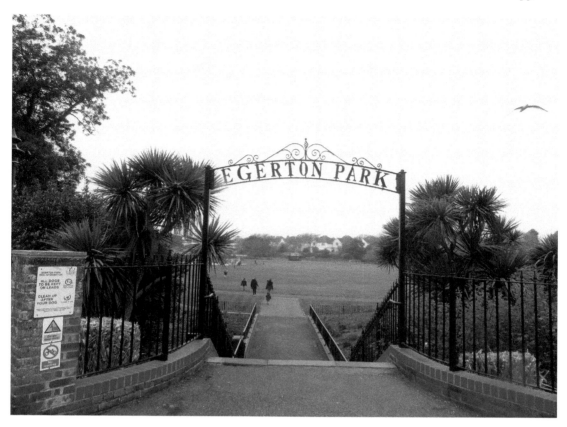

Egerton Park.

Charles Dawson's First 'Missing Link'

Sussex archaeological circles were graced at this time by a Mr Dawson, who famously went on to find a 'missing link' between apes and men. He found time to involve himself with a matter in Bexhill.

When the Egerton Park site was being dug over, workmen discovered an old wooden boat buried in the ground. The fabric of the boat was all oak held together with wooden pegs. J. W. Webb decided to recover the boat, and set his men to excavating it. Unfortunately, this kind of work – with thick sands and a near-rotten vessel – requires delicacy. The excavation was carried out too brusquely, and the boat, 'of a distinctly antique and curious pattern', was pulled out in pieces. This story was reported in January 1888. It was thought to be a 'primitive shallop in which cattle and horses were not infrequently "lifted" by longshore thieves'.[1]

In 1893 the Sussex archaeologist Charles Dawson described a boat excavated at Bexhill. It was made of oak, with wooden pegs holding the boat together, but this boat had a very romantic provenance. In the winter of 1887, we are told, the movement of the sea displaced the sand on the shoreline, and the lines of a buried boat appeared. Jesse Young, a local boatbuilder, went with friends to excavate it, a dangerous task: 'The work

34

was undertaken on a bitterly cold night and with the sea almost at their heels, with the dreaded sand, the men dug out the boat.'[2] Needless to say it was in pieces when they took it back to Jesse's yard.

DID YOU KNOW?
The south coast became a popular resting place for deposed monarchs. In 1849, while St Leonards was home to the ex-king Louis Philippe of France, Bexhill was home to Don Miguel de Braganza, one-time king of Portugal. He was an enthusiastic supporter of absolute monarchy, but in Bexhill he had a modest following of a single cook, a valet and a maid.

Unless an astonishing coincidence was at work, there was only one boat found, with two different stories attached. Dawson told the more gripping story of the boat's discovery and he added other elements. Many years before, he said, by Martello Tower 48, west of Bexhill, the skull of a horse had been revealed, along with a large number of hazelnuts. This skull was sold to a man from Hastings and never seen again. The implication was that the horse was being transported by boat before a tragic and watery end. According to Dawson, the Bexhill boat was in itself a very significant find. From the bits and pieces before him, he could build a picture of a truly remarkable vessel. Its construction suggested what he described as 'a link' between a simple coracle and a boat in the Bayeux Tapestry. This had important implications for the evolution of the British boat. Charles Dawson had found his first 'missing link'.

Dawson was later celebrated for a set of astonishing archaeological discoveries. Later still, he was reviled for them. Sometimes he found astonishing things in the ground, and sometimes he was standing around when someone else found them. At least thirty-eight of these discoveries are now considered as fakes. Dawson's career reached its zenith in 1912, when he discovered a jawbone and teeth at Piltdown, 30 miles from Bexhill. Many in the scientific establishment were convinced that Dawson had unearthed the 'Missing Link' between man and ape. In reality, the bones were a mixture of modern human and modern orang-utang. 'Piltdown Man' has since become the classic scientific hoax. There was one group, incidentally, which never believed in the veracity of the Piltdown finds. This band of doubters was the Sussex Archaeological Society, whose members had come to know Dawson very well.

6. The Dawn of the Twentieth Century

India-on-Sea

By the early years of the century, Bexhill-on-Sea had taken shape as a seaside resort. It had daringly allowed men and women to bathe from the same beach. New hotels had been built and the town even had its own Bexhill Mineral Water, bottled in Western Road and served in the hotels and restaurants. The Kursaal was, like Brighton's Place Pier, influenced by Palais de la Jetée in Nice. On a sunny day, looking west from Galley Hill, we can imagine how Bexhill might have emulated the elegant sweep of Nice's seafront.

Rail communications were good, and an imposing new station was completed in 1902. The access to the platforms, down sweeping ramps, is on a grand scale. It was later said that the platforms had been extended to hold the funeral train of the Maharajah of Cooch Behar when he died in 1911. This seems to be untrue, like the story that the Maharajah kept a harem of ladies in the buildings of Marine Arcade. The Maharajah did in fact have one apartment there and Marine Arcade, completed in 1907, shows a distinct Moghul influence.

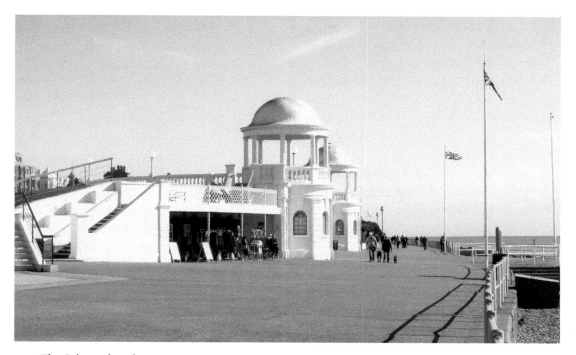

The Colonnade today.

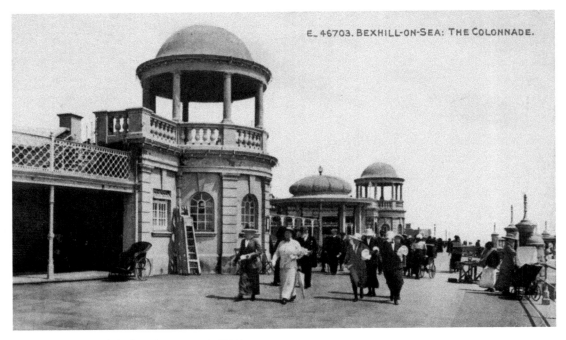

E. 46703. BEXHILL-ON-SEA: THE COLONNADE.

The Colonnade before the First World War.

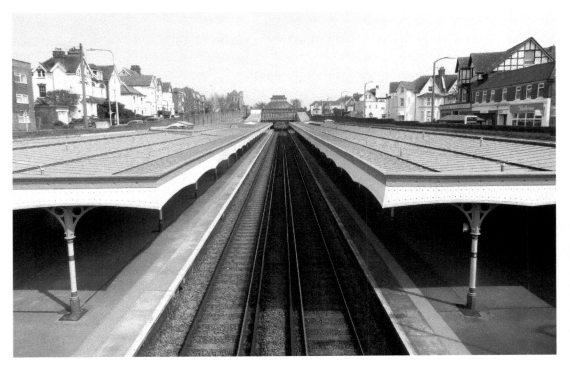

Bexhill railway station.

Above: The Henry Lane memorial fountain.

Right: Henry Lane of the 5th Bengal Light Cavalry.

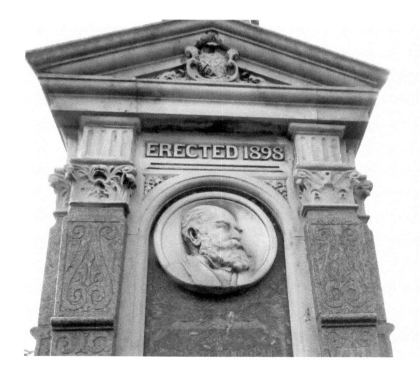

ERECTED 1898

The Mughal style.

This era was, of course, the high point of the British Empire, and Lord Curzon, Viceroy of India, stayed at the Sackville Hotel. In the early part of the century many imperial servants and soldiers came to Bexhill to retire. Those who were still serving the Empire overseas sent their children to school in Bexhill. Later, in the 1950s, Atul Chandra Chatterjee, Indian High Commissioner, retired to Bexhill and lived at Motcombe Court. In front of the Town Hall is a monument – a drinking fountain – dedicated to Lt Colonel Henry Lane, who had worked hard to build local government in the town. The fountain was erected in 1898. Forty years earlier, as a young officer, Lane had fought in the Indian Mutiny and had been at the relief of Lucknow. At least we still know where Lane's fountain is. The Maharajah gave the town an imposing stone drinking fountain, which was temporarily moved from Egerton Park and was then mislaid, never to be found again.

The Birthplace of British Motoring

The 8th Earl was keen on progress and Bexhill was to be a modern town. In 1902 the borough's documents of incorporation were delivered by motor car. The earl will also have been aware that in Nice there were motor races beginning on the Promenade des Anglaises. In the same year Bexhill heard that it was to be location for automobile speed trials, sponsored by the Automobile Club. Striking a very modern note, a distance of 1 kilometre was carefully measured along the seafront. The timing was to be done by electricity, and there might even be ladies' races. There were petrol cars, electric cars and steam cars.

For four days over the Whit weekend in 1902, Bexhill was full of motor cars and full of visitors. The hoteliers were delighted. Whit Monday itself was marred by frequent showers, but the speed trials nonetheless went ahead; the national publicity for Bexhill was just what the hoteliers wished for.

The course itself had presented the drivers with problems. As so often with Gilbert, the grand vision was let down by the details. M. Léon Serpollet, the famous French

The starting line for the 1902 trials.

The finishing line for the 1902 trials.

racing-driver, and Baron Henri de Rothschild had inspected the course. They did not like it. There was not enough road to slow down at the finish, and the main course had too many bends. The promise of rain made the matter worse. In a compromise it was agreed that small cars could race side by side, but the larger vehicles could not.

In the speed trial, M. Serpollet was the overall winner, driving a steam car called *The Easter Egg*. It was reported that over a 500-metre stretch of the course he had achieved 80 miles per hour, but the bends in the course meant that he could not maintain this speed for the full kilometre: he coasted for the last part of the course, with a recorded speed of 54 mph. At Nice a few weeks earlier, he had covered a measured kilometre at 75 mph. Even so, the meeting was a tremendous public success and the *Daily Express* called Bexhill 'Motorville-on-Sea'.

Bexhill has since claimed that this was the site of the first international motor race in Britain and of course there are counter claims. There had been some races on private property and there had even been an international race in Glasgow in September 1901, using a cycle track. Perhaps the Bexhill meeting should be regarded as a speed trial not a true motor race, but the Bexhill meeting was the first spectacular public event in a sport that has spectacle at its heart. The event attracted important drivers, including Mr Rolls, later of Rolls-Royce fame. It was officially sponsored by the Automobile Club, attracted a large amount of newspaper coverage and also drew 20,000 people.

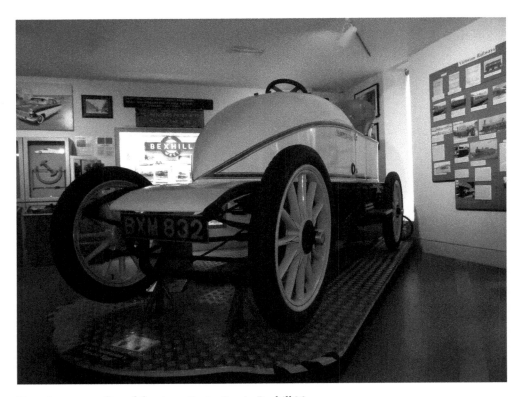

The winner: a replica of the steam Easter Egg in Bexhill Museum.

The Wheel Comes Off

Many of the spectators had driven down to Bexhill to watch the event. On the journey back to London, the Sussex police were lying in wait for them. One officer, we are told, lay in a field and measured the time that motorists took to cover a quarter of a mile. If the motorist was speeding, the policeman signalled to another officer who would jump out in front of the vehicle and make his arrest. A Manchester journalist was stopped in this way. After being charged he drove back along the road and warned ten other motorists to slow down. A Mr Edwin Midgley had saved at least fifty other motorists from being charged at East Grinstead. His servant had noticed the police setting a trap and had signalled to the approaching motorists to slow down. This was obviously legal behaviour in those far off days. On 19 June twelve of the motorists were sentenced at the Uckfield Petty Sessions for speeding. Most of those charged did not bother to appear in court, and the magistrates complained that the accused settled the bill as though the court were a grocer's shop.

Earl De La Warr was very pleased with the event. He had agreed with the Automobile Club that there would be up to twelve meetings a year, and he set about improving the course. Difficult angles were to be smoothed away, and the course was going to grow by 200 yards. The next meeting was due on the August bank holiday.

There was, however, bad news on the way. The earl had acted as though he owned the all of the Marina. In fact, he owned almost all of it. A small section had been sold to Mr William Mayner, a speculative builder. Mayner did not live in Bexhill – he lived in Hove actually – but argued that the simple fact of a motor race prevented private

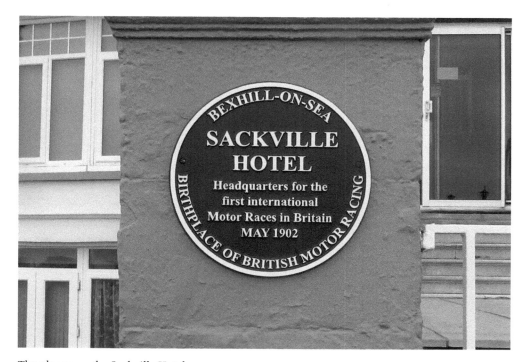

The plaque on the Sackville Hotel.

individuals from accessing their property. The courts agreed with him. Perhaps Earl De La Warr did not have the right to turn the road into a racetrack. Bexhill's great age of motoring had come to an end almost as soon as it started.

It is not clear how Earl De La Warr squared things with Mr Mayner, but in 1904 there was another meeting at Bexhill. This time the direction of the race was reversed: contestants started by the De La Warr gates and raced up to Galley Hill, where a disappointingly small crowd waited. Many of the spectators did not wish to make the journey to the top of the hill. This was a smaller occasion where races were restricted to touring cars. Motor racing was becoming faster, but there were also more regulations. A Mr Graves won a race, but was disqualified because his passengers weighed too little. The rules said that the vehicle should have four occupants with a combined weight of 40 stone, but Mr Graves had some lightweight individuals in his car who, between them, could only manage 37 stone.

DID YOU KNOW?
In January 1920 Florence Shore, a fifty-five-year-old woman, was found unconscious and battered in a third-class compartment at Bexhill station. She had been on her way from London to a holiday in St Leonards when she was attacked, and died a few days afterwards. There were two false confessions to her murder, but the case has never been solved. Florence, a nurse from Sunderland, was named after her godmother, Florence Nightingale.

By 1905, the town – or at least its newspaper – had had enough of motor racing: 'In the present state of the public mind, motor races cannot be a good bait to catch the class of visitor on whom Bexhill depend.'[1] In 1906 there was a serious plan to build a real motor circuit starting at Cooden Beach and stretching across the Pevensey Levels all the way to Beachy Head. Sadly, the racetrack did not come into existence and in 1907 Brooklands was built in Weybridge, Surrey. Bexhill still had the occasional meeting on the Promenade, and some very fast times were recorded in the early 1920s. The glory days, however, were over.

Mr Grindell Matthews and his Death Ray

By May 1906, Bexhill had many cars on its streets, and one driver found himself on trial in Hastings, charged with driving a car in a dangerous manner. The incident happened in Station Road, Bexhill, where a Mr Tutt of Western Road said that he had been knocked off his bicycle by Harry Grindell Matthews. An independent witness, who had been pushing a wheelbarrow up the street, recalled that the car was travelling at 15 or 20 mph. He remembered the number plate – LC3991 – on a red car, which had been seen in the morning on a smaller blue car. Matthews said he had been driving a green Argyll car, number plate LC3991. He had been travelling, he said, at second speed, which meant a maximum of 8 mph. Questions about the colour of the car or cars were left unanswered and Matthews was found guilty.

Harry Grindell Matthews (1880–1941) was at this time working as a consulting engineer for Earl De La Warr, who was always interested in new technologies. The renovated manor house in Old Town had electricity and boasted its own electric telephone system, but the consulting engineer was not restricted to household electricals. Matthews spent seven years in Earl De Lar Warr's employ and was encouraged to range widely over possible technologies. Matthews had left school early, but worked for an electrical company and was a visionary. He had been injured twice in the Second Boer War, serving in Baden Powell's South African Constabulary. Earl De La Warr had, of course, been injured in the same war, and Matthews' war record gave him access to government departments. In Bexhill the young engineer was given a small laboratory, and Earl De La Warr would often call by to see what was happening and to offer encouragement.

DID YOU KNOW?
Grindell Matthews was fortunate to marry Ganna Walska, a Polish opera singer. She had a limited operatic talent, but had four very rich husbands and was satirised in *Citizen Kane*. Matthews, her fifth husband, benefitted from this wealth, but Ganna was soon involved with a yogic master who became her sixth husband in time.

As well as this small laboratory, Matthews was also given a small wooden hut on top of the Kursaal. From here he proposed to send messages by wireless telephony, and was said to have successfully communicated with a rowing boat 3 miles away. He was meant to demonstrate his invention to members of the Royal Navy in late 1907, but the demonstration was called off. His claim was that he could communicate by voice with the Sovereign Lightship, 8 miles away. He could use the same technology to control a torpedo, and he was planning to guide a custom-built torpedo from the Kursaal to the Lightship. He hoped that his 'aerophone' – like the modern mobile phone – could be used to detonate explosives at a distance.

In the 1920s he became famous as an inventor. He had a claim to have invented the talking movie, recording a talking Ernest Shackleton in 1921. He transfixed Londoners when he projected giant pictures onto the cloud above the city. He also had plans to set up radio stations on offshore ships to counteract the BBC's broadcasting monopoly. Some of his inventions did work. The government paid him in £25,000 during the First World War for an invention that used selenium cells to control motor boats remotely. Sadly, he became world-famous in 1923 for his Death Ray Machine. In fairness, his original claim was simply that he could stop an engine from a distance. He demonstrated that he could stop a moving motorcycle at close range, although the experiment would not work if the engine was protected by a lead coating. As always, Matthews became over-enthusiastic, foreseeing a future where ships and even explosives would be affected by his death rays. He consistently claimed more than he could deliver, produced films of his devices that are highly questionable and was unnecessarily secretive about the contents of his inventions – a pity. If he had been more forthcoming in 1907, Bexhill could now claim to be the birthplace of the British radio broadcast and the birthplace of the mobile phone.

7. The Aristocrats

The marriage of Gilbert Sackville, Viscount Cantaloupe, to his bride Lady Muriel Brassey was in many ways a typical upper-class wedding of the late nineteenth century. Gilbert came from a distinguished and ancient family, the De La Warrs (pronounced Delaware, like the US state that took their name), and could look forward to becoming the 8th Earl De La Warr. Muriel Brassey came from a very rich family and could look forward to remaining very rich. Her family's money came from railway building. Her grandfather Thomas Brassey (1805–70) built a large proportion of the world's railway lines and was part owner of Brunel's Great Eastern. Her father, also Thomas Brassey, held significant posts in government and commerce, and was made Earl Brassey. Gilbert's parents felt unable to attend the wedding: the Brasseys were undeniably rich but too decidedly nouveaux for the De La Warrs.

The wedding was in London on 4 August 1891. Muriel looked slight and elegant in her white duchess satin and the maids wore 'Kate Greenaway' costumes. After a honeymoon in the Black Forest, the happy couple moved to Bexhill, staying for two years at the family residence at the Sackville Hotel. They spent a large amount of money making the manor house fit for their habitation.

The manor house after modernisation.

The manor house was designed as a home but also as a place of entertainment. There were pastoral plays in the grounds and evening parties when the gardens were lit with fairy lights. When Gilbert's father died in 1896, Gilbert became the 8th Earl De La Warr, and the couple must have felt very happy. They threw themselves into the life of Bexhill. They ran the local hunt and every local organisation seemed to include the earl as a patron or chairman.

The 8th Earl

Money was a problem for the new earl as his business ventures tended to go wrong. He became chairman of the Dunlop Pneumatic Tyre Company, and apparently employed many clerks in Bexhill to help with the job. Quite what they did is unclear, since the earl's only qualification for the post was his aristocratic title. His partner, Ernest Hooley, was offering inducements to him to recruit other aristocrats onto the boards of various companies: '£10,000 to recruit a Duke, £5,000 for a couple of ordinary peers'.[1] These ventures – typically but not exclusively connected with tyres and bicycles – crashed spectacularly when Mr Hooley was found to be a fraudster.

The public were, of course, delighted to see the aristocracy accused of monumental sleaze. At Hooley's bankruptcy proceedings, the galleries were filled with avid spectators, who were not to be disappointed. Not only did Hooley accuse the earl of accepting inducements, such as a payment of £2,000 for recruiting Lord Greville, but he also said that the earl had offered him £1,000 to change the statement he was planning to make during his bankruptcy proceedings. As a result, the earl came very close to being found guilty of contempt of court. To try and extricate himself from the mess, he offered to pay back all of the money that Hooley had given him. By the end of 1898 Gilbert was no richer because of his business activities – he was poorer in fact, and was now also a subject of ridicule and distrust.

There was one way to reclaim his standing. Like many a disgraced aristocrat in fiction and in life, he could restore his reputation on a foreign battlefield. The Second Boer War presented the opportunity, and on 14 October 1899, Gilbert set sail for South Africa on board the *Dunottar Castle*. He was one of two newspaper correspondents on board, the other being Winston Churchill. In May 1900 he was wounded at a skirmish at Vryheid, attempting to rescue a comrade, and was interviewed by a newspaperman. His account of his actions showed him in a heroic light, and his reputation was restored. On his return it was reported that 50,000 people gathered in a flag-bedecked Bexhill to welcome him.

When he returned from South Africa in July 1900, relations between Gilbert and Muriel became extremely unhappy. This was despite the fact that Muriel had given birth to a son in his absence: Herbrand Sackville, born on 20 June 1900. With the earl's behaviour deteriorating, the couple were soon to be involved in a divorce case.

Gilbert George Reginald Sackville, 8th Earl De La Warr (1869–1915), could walk around Bexhill and feel at home. The town had a Sackville Road and a Sackville Hotel, as well as a De La Warr Road. From 1890 to 1896 he had been styled Viscount Cantelupe, and there was indeed a Cantelupe Road close to the sea (but sadly also close to the gasworks). The Sackvilles had once been Dukes of Dorset, so there was a Dorset Road. Young Herbrand Sackville was also known as Lord Buckhurst, and there was a Buckhurst Road and a

Herbrand Walk. Muriel's maiden name of Brassey provided another street name, and the town's street names refer to family homes at Knole and Normanhurst.

Gilbert could also pace his way about the town noting the addresses that had cropped up in various court proceedings. The most famous of these was his divorce from Muriel in 1902. Gilbert had been unfaithful to Muriel over the years, but in 1901 his behaviour reached new depths. While Muriel still lived at the manor house, Gilbert moved into the Metropole and held a series of parties, to which Muriel was not invited. At Christmas 1900 he had met an actress who was performing at the Kursaal. (One member of the Sackville family has referred to her as a can-can dancer.) An affair blossomed, and Gilbert was able to write to Muriel about his passion for the 'tall and fair' Miss Turner. Then in December 1901 the actress was booked into Bexhill for the Christmas season. This was too much for Muriel and a divorce case ensued. One minor feature of Gilbert's cruelty needs to be noted. In his letters to Muriel he talks only of Miss Turner, and newspapers at the time noted hat the actress did not give her Christian name in court. According to Muriel De La Warr, the actress was advertised to appear at the Kursaal: the notices for the Kursaal that Christmas show a 'Muriel Godfrey-Turner'.

The divorce was finalised in 1903, and in September of that year Gilbert married. Miss Turner had obviously disappeared by now, and Gilbert married Hilda Mary Clavering Tredcroft. They lived at Marina Court when they were in Bexhill. This marriage also ended in divorce.

In 1909, Gilbert found himself in a Scottish court, being questioned about improper activities with a Nancy Atherton in a bungalow in Bexhill. In a fine piece of courtroom theatre, a French maid of Mrs Atherton's, with the splendid name of Therese Dagonne, had alleged that there had been improper conduct between a gentleman and Mrs Atherton. The French maid wrote down on a piece of paper the name of the gentleman. Summoned as a witness, Gilbert said that he had known Mrs Atherton in South Africa, but he denied any improper conduct.

In 1913, at his Cooden Beach Golf Club, Gilbert met Charles Sydney Skarratt, a theatrical manager from London. Gilbert also met Mrs Mabel Skarratt, an American actress and another divorce case began to brew. The golf club was a convenient spot for Gilbert and Mabel to meet, especially with her husband being such a keen golfer. By the time of this

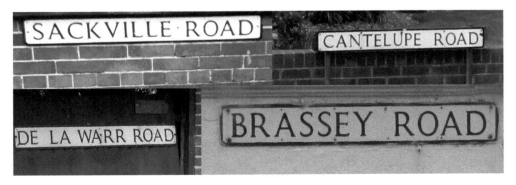

The various names of the De La Warrs recorded in Bexhill's streets.

divorce case, Gilbert had died in the war, so in this instance he did not have his day in court. Mr Skarratt did, however, obtain his divorce.

Muriel

Muriel De La Warr was the daughter of a millionaire (and Liberal MP) who became an early member of the Labour Party. This was in part due to her early adoption of suffragism. The National Union of Women's Suffrage Societies decided in 1912 that it would back Labour candidates. Muriel helped organise the Election Fighting Fund alongside Millicent Fawcett. She was a close friend of George Lansbury, future leader of the Labour Party. She gave substantial sums to Lansbury to keep the *Daily Herald* afloat. 'One name', said Lansbury, 'should always be held in highest esteem by our movement, and that is 'Muriel Countess De La Warr'.[2]

Muriel, as well as being a keen supporter of the socialist movement, had an interest in eastern esoteric philosophy. She became a member of the Theosophical Society, a grouping that followed instructions sent to them by mystical masters living high up in the Himalayas. Over time, the masters communicated that a young Indian boy was to be selected and trained as the new World Teacher.

The World Teacher was Jiddhu Krishnamurti. The Theosophists were determined to take the new World Teacher and his brother to England. Neither of the boys wanted this (nor did their father) but they were in no position to argue.

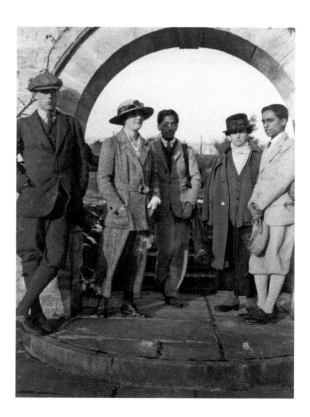

Muriel (right) with Herbrand (left) and Jiddhu Krishnamurti (centre). (Krishnamurti Foundation)

At this point Muriel entered the story. On his arrival in England, Muriel was able to offer a house for him to live, Old Lodge in the Ashdown Forest. Here Krishnamurti and his brother could be educated. The isolation of the house – and the provision of security in the form of two bodyguards – meant that the brothers would not be kidnapped (by their father).

DID YOU KNOW?
Muriel had two daughters. The elder was Lady Idina Sackville, who became famous for her five marriages and five divorces. After leaving England and her children, she became a part of the louche Kenyan Happy Valley set, dramatised in the film *White Mischief.*

She was able to provide the money for Krishnamurti's education. He was intended to go to Oxford, but Oxford would not have him. There are signs that Muriel was unhappy with this turn of events. She was concerned that the new World Teacher might be frivolous, and she wanted to ensure that he paid his debts by service to the Theosophical Society. It was not clear whether Krishnamurti, as World Teacher, was master or servant.

Later in the twentieth century, Krishnamurti was acclaimed as a profound spiritual leader, but not in the way that Muriel and her friends had hoped. Through his twenties, he was guided and moulded into the role of World Teacher, and given control of the Order of the Star of the East. Then in 1929, at the age of thirty-four, he called his followers together for an announcement: the order was a waste of time, and was to be disbanded immediately. Truth, he said, is a pathless land, and he did not want any followers. His loyal followers were deeply disappointed.

8. Adventurers

Kate Marsden

Before the First World War, Bexhill was home – or a summer home, at least – to aristocrats and the very rich, along with their army of imported and local servants. The town also had a noticeable population of shopkeepers and hotel staff. As a fashionable resort with a drifting population, Bexhill also harboured another group: those residents who lived a genteel life, but whose fortunes were uncertain or obscure.

Bexhill owes its current museum to one of these people. Kate Marsden (1859–1931) arrived here in 1912, in the company of the Norris sisters. The Norris sisters were the daughters of a clergyman, and were devoted to Kate. She could inspire devotion in people, though one of her detractors describes her as 'having an old lady under thumb'[1] and of living off the Norris sisters for thirty years.

Kate had begun her working life as a nurse and went to work in New Zealand in 1884. After some controversies there, she returned to Europe in the company of a Miss Ellen Hewitt. These two women then travelled around Europe, with Miss Hewitt paying the bills. After a disagreement, Miss Hewett reported that Kate had hit her hard and left her

The Bexhill Museum.

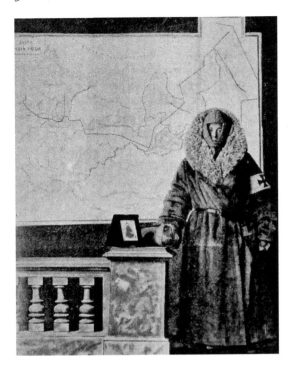

Kate Marsden, dressed for Siberia.

severely injured. Nonetheless, Kate was soon to be a famous woman, highly regarded by Queen Victoria. In 1891, with the support of the Russian royal family, she went on a long expedition through Siberia. She was travelling through that inhospitable landscape to establish the condition of the lepers there, and to see if a particular plant could be used to cure leprosy. On her return she gave talks on the subject to the great and the good; at one meeting she addressed the Duchess of Teck and Mr Baden-Powell. She was received by the queen at Balmoral, and became the first female fellow of the Royal Geographical Society. Her travels were recorded in her book *On Sledge and Horseback to Outcast Lepers* (1893). It was a successful publication and as a result of her fame she was able to send significant amounts of money to build a Siberian leper hospital.

Unfortunately, her rise to fame stirred her many detractors, especially an American writer called Isabel Hapgood. For Hapgood, Kate was little more than an impostor, a woman who travelled in luxury and fabricated tales of hardship. Other critics said that Kate had no need to visit Siberia at all: she was not visiting as a nurse, and the territory had very few lepers anyway. The plant that she was interested in had already been investigated in European laboratories. The Charity Organisation Society declared that her work in Siberia was neither 'necessary nor practicable' and that she herself was unsuited to the financial management of this kind of enterprise.

According to her critics, Kate was a self-seeking adventurer who exploited the good nature of devout old ladies; she had exaggerated her exploits, both in New Zealand and Siberia; she was prone to bouts of madness; she was a papist; she was guilty of insurance fraud; and she had 'immoral relations with several women in different countries'[2].

Dorset Road, home of Kate Marsden and the infant Angus Wilson.

All of this must have seemed safely behind her when Kate came to Bexhill with the Norris sisters. They moved into No. 61 Dorset Road, which they called Silver Willows. Kate had an interest in the natural world and was on the beach one day, collecting shells, when she encountered the Revd J. C. Thompson. Before long these fellow enthusiasts had agreed to set up a museum. In October 1912, a group of Bexhill residents met to create the institution. They gathered at No. 61 Dorset Road and formed a provisional committee. The committee included a JP and an admiral, as well as the Revd J. C. Thompson, who was able to interpret the Corporation's views on the matter.

Kate was the charismatic force behind the project and had offered up her own collection of shells. She had contacted the mayor of Bexhill, asking if the Shelter Hall in the park could be used. This permission was forthcoming, with the understanding that the shelter would still function as a park shelter. Miss Marsden, as a fellow of the Royal Geographical Society, could draw upon its 4,000 members to make contributions. A Miss Boldero, who lived across the road from Kate, offered to provide a collection of snails. There was an agreement that the children of Bexhill would benefit from such an educational establishment.

Miss Marsden acted as a human dynamo, ensuring that the local council and local business were kept on board, and all the while promising not to burden the local taxpayer. There was a proposal in December that the local commercial community should be represented on the committee. In January she presented her ideas for a museum in the shelter – what was now called the Park Pavilion – to the local Chamber of Commerce. The business community was delighted at the project, and also at Miss Marsden's advocacy of

a technical college for the town. Mr Robbins of the Chamber said that her name should be 'written in gold in the annals of Bexhill'.

In February 1913 there was an exhibition at Dorset Road. There were shells and butterflies and an account of economic activities in each of the colonies. There were, however, some rumblings about the scale of the project. What had begun as a few shelves in the park shelter was threatening to take over the building.

DID YOU KNOW?
In 1909 Bexhill's first 'Votes for Women' meeting was attended by militant suffragette Mrs Dilks of Eastbourne, who had recently attacked the prime minister's home. Mrs Fawcett came to the town in November of that year to address the Bexhill Literary Society. In 1913 an attempt was made to set fire to two bungalows at Cooden Beach; suffragettes were suspected.

Then, early in 1913, a bombshell landed. Somehow the mayor of the town had been informed of Kate's past. He informed the Revd Thompson, who asked Kate if there was truth in the various charges. She 'bowed her head and confessed there was'.3 After this, Kate became ill and the Museum Committee had to carry on without her. The committee were far from happy at this turn of events, but struggled on. For some in the town, it was time to end the museum project, which was simply 'a fad of a lady'. The Revd Thompson persevered, and the museum did come into being in 1914. Kate and the Norris sisters moved to a house at No. 15 Cooden Drive (also named Silver Willows). Years later, the Norris sisters offered the museum a portrait of Kate. The museum – specifically the Revd Thompson – turned it down.

William Forbes-Leslie

In 1912, Dr William Forbes-Leslie was living at No. 22 Marine Court Avenue. He had visited earlier, staying at the Sackville Hotel. Forbes-Leslie had a talent for fiction and published stories in the *Boy's Own Paper*. He wrote travel adventure books, which were probably also fiction. In 1904 he explained at a bankruptcy proceeding that he was entitled to be called the Duke of Villanda, because his wife was the Duchess of Villanda. His wife did indeed style herself as a duchess, but was in fact Adelaide Ivy Elizabeth Williams. At a fraud trial in 1911 the judge described her as 'an accomplished swindler'.

William Forbes-Leslie was born William Patterson. He qualified as a doctor and tried to set up an alcoholic drinks business. By 1912 he was presenting himself as an eminent geologist, and was campaigning to open up the oilfields of Norfolk. He became managing director of an oil exploration company, which raised plenty of capital but little usable oil. From No. 22 Marine Court Avenue, he attempted to set up a construction syndicate to profit from the Portuguese revolution of 1910. One of his letter books turned up by accident during some buildings works in Pevensey, and they offer a picture of a

remarkable business venture. The new syndicate held out breathtaking possibilities for its investors: railways, diamond mines and the Port of Lisbon docks. All of this was possible because of Forbes-Leslie's supposedly deep contacts in the new Portuguese government. The letters show him assuring his investors that he is close to the regime. They also show him desperately trying to make contact with an individual in Lisbon to find out what was happening there.

It was a fairly disreputable life, but one must admire his tenacity. In 1935 he was not only declared bankrupt at Carey Street but was also appearing at the Old Bailey charged with fraud. He was declared 'a dangerous and plausible criminal' and was sentenced to two years in prison. He was seventy years old.

William Johnstone-Wilson (and Son)
Like William Forbes-Leslie, William Johnstone-Wilson had a gift for exaggeration. He had started out life in Scotland, where the family had an estate called Dunscore. After a few feints at finding a profession, he decided to be a gentlemen of independent means. He started life with a reasonable amount of inherited capital, which might have lasted him for a modest lifetime. Edwardian England had plenty of such rentiers, people living on their forefathers' prudent investments, but Willie was sure that further inheritances would bolster his income and spent accordingly. He was sent off to South Africa in disgrace, and there he met his wife, Maude. Maude was accustomed to having native servants and moved to England expecting a life of sophistication. They began married life in a respectable house in Richmond and had several sons. The money, meanwhile, was running out. Willie's capital was exhausted and there were raids upon his wife's income. He invented tall tales to borrow money and to avoid repayment. The family became accustomed to sudden changes of address, again to avoid paying the backlog of rent. There were moments of relative prosperity, when he was lucky at the racecourse. After a few years of dodging creditors in London, they moved down to Bexhill shortly before the First World War. Willie was forty-eight and Maude was forty-four. 'If my father had ever known employment,' said his son, 'one might have spoken of him as in retirement.'

They had their own house at No. 57 Dorset Road – just two doors from Kate Marsden. They named their abode Dunscore after the family's ancestral home. Maude's sixth pregnancy came as a serious shock to them both. Their sixth son was born on 1913, and they named him Angus. Maude had always wanted a daughter and compensated for the disappointment by giving her son ringlets. Before long, the Wilsons had left Dorset Road for an apartment at No. 4 Marina Court. The new address had many advantages. It was a very modern apartment block, with hydraulic lifts and electricity. Of especial interest to Maude, there was the Christian Science Reading Room downstairs, and they had friends among the older retired people in the block. However, this was a step back towards a nomadic life. Over the coming decades, the Johnstone-Wilsons were on the move. Sometimes they stayed in decent hotels with gold lettering on the door, and sometimes in hotels with ordinary lettering. Still worse, the family sometimes lived in boarding house and even ate at a common table with the other guests. Maude's children were under strict instruction to refer to these establishments as 'private hotels'.

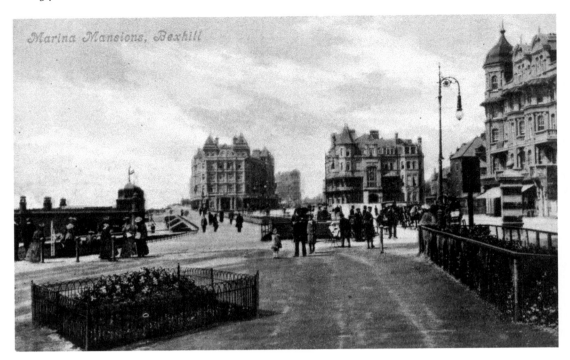

Marine Court (the block on the centre-left).

Edwardian England knew plenty of this fretful, genteel poverty. The Johnstone-Wilsons were unusual only in having a son who understood from an early age what was happening. Angus was a precocious child and the insecure world of the apartment block gave him a first insight into the terror lurking just beneath the social veneer. After he left school he worked in a set of casual employments, then took a job at the British Museum. In the Second World War he worked at the Bletchley code-breaking centre where he was known as 'a brilliant young homosexual'. Then, one weekend in 1946 he began to write stories. By the 1950s, Angus Wilson was being feted in the literary world. Much of what we know about his Bexhill years, for example, comes from a set of talks about himself that he was invited to deliver in California in 1953. His short stories, and novels such as *Anglo-Saxon Attitudes,* almost marked him as a great modern author. He was also a literary critic and was very influential as a professor at the University of East Anglia. If he had been personally nicer, and if he had died sooner, his reputation now might have been greater.

Angus Wilson has left us some pictures of his life in Bexhill. 'My early childhood during the First World War was spent neither in town nor country, but by the seaside where summer mornings on the beach alternated with afternoons catching butterflies or grasshoppers in the lush meadowland that surrounded my father's tennis club.'4 He describes the seashore: 'ribbon weed clear like coal tar soap, of plimsoll rubber slipping upon seaweed slime.'5 He came to fear the sea in a way, learning that gunfire could be heard from across the Channel on a still day, and aware that bad news about his brothers would come at any moment from the other side.

Children at the Bexhill seaside.

While his son waited by the sea listening for the guns, Willie Johnstone-Wilson was complaining about the rising cost of foodstuffs. As a rentier of limited means, he was right to be worried. Over the next decades, inflation would wipe out his social class.

In 1915, we are told Bexhill was having a record season, although there was now a preponderance of women and children among the visitors. The Kursaal was renamed, obviously, to replace the Germanic name with the more acceptable 'Pavilion'. The town maintained its respectable demeanour. According to the *Bexhill Quarterly* for 1915, 'The objectionable class of excursionist is not catered for in Bexhill. There are no Pierrots or minstrels allowed in the beach.'[6]

9. Between the Wars

The Arrival of the Residents

Before the First World War, Bexhill advertised itself as a holiday resort, albeit of a very refined kind. The town's brochure from around 1910 is aimed squarely at the occasional visitor. It talks of luxurious hotels, well-appointed houses and pleasure gardens, offering a happy mean between the overcrowded seaside and the dreamy village by the sea. The town developed in a new direction. By 1921 the population had reached 20,000 and many of the new population had come to Bexhill to retire.

By 1937 the new town guide talks of the 'exceptional advantages for permanent residence by the sea'. The guide is introduced by Mr Cuthbert, the mayor: 'My own experience is perhaps that of many retired people – I came to Bexhill in search of a healthy, clean quiet seaside place.'[1] He goes on to add that Bexhill has its open sea, so has no need to invest in enclosed baths. This is the voice of a new Bexhill: comfortable, seeking quiet rather than entertainment, and very unwilling to invest in tourist attractions. It was as a quiet and rather dull residential town that Bexhill featured in literary works of the 1930s.

Birthplace of Modern Thai Literature

Bexhill-on-Sea was, according to one young novelist, 'a calm, clean and dazzlingly beautiful place ... the air was deliciously cool and refreshing. The waves broke along the shore at regular intervals in splashes of white foam.'[2] The novelist is Prince Arkartdamkeung Rapheephat (1905–32) – we will call him Arkart – and the novel is *The Circus of Life* (1929). It is known in Thailand as the starting point of modern Thai literature and visitors from Thailand will sometimes make a pilgrimage down to the coast to see the house where Arkart stayed. The novel – in many parts a thinly disguised autobiography – is set in the world's cultural capitals: London, Paris, New York, Shanghai and, as mentioned, Bexhill.

Arkart came to stay in the town in October 1923 and left early in 1924. According to his biographer, he stayed at a house called Queen's Cottage, owned by a Captain Fraser. In the novel the hero stays at Queen's Cottage in the company of Captain Andrew. Captain Andrew is a red-faced gentleman, first seen in his golfing clothes, who acts as a father-figure. In reality there was no Captain Andrew, nor was there a Captain Fraser. There was, however, a Queen's Cottage, which – as in the book – was located in Middlesex Road It was 'a nice two-storey house with beautiful green plants creeping along its walls.' This house was occupied in 1924 by a Captain Prescot, who was in the RAF. Proper names are often mangled in translation, and this may be the 'Captain Fraser' mentioned by Thai commentators. We do not know why Prescot would be entertaining a Siamese guest. It might possibly be relevant that Arkart, as well as being a prince, had a father very highly placed in the Thai government. Queen's Cottage is still there in Middlesex Road, but has changed its name. It became an hotel, the Victoria Hotel, then reverted to being a private residence called Victoria House.

Victoria House painting. (Raouf Oderuth)

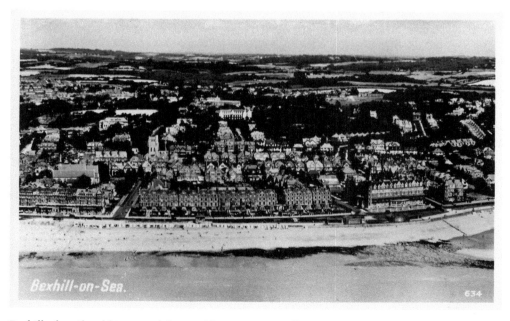

Bexhill when the old town and the seaside resort were still separate.

In the novel Middlesex Road is near a restaurant called the Seville. Perhaps this refers to the Sackville, the hotel at the bottom of Middlesex Road. The book describes how the hero and his girlfriend walk down to the sea and look over to St Leonards and Hastings. Some contemporary details in the novel are interesting. The hero dresses in a jumper and plus fours, while his girlfriend dresses informally in a dark brown skirt and a jumper with dark stripes. The Andrews family eat in a modern fashion, on a shiny lacquer table without a tablecloth.

Other details, however, seem slightly odd. The Andrews call each other 'Elsie' and 'Bertie'. Captain Andrew goes for a ride along the beach after church on Sunday. A car journey into Eastbourne takes two hours. The home arrangements of the Andrews family seem unusual: the mother and daughter share a room while the father has a bedroom of his own. When guests come, he vacates his room and shares a bedroom with his wife and daughter. It is in this unusual world that the fictional hero decides to write a novel. He declares to his English girlfriend – while standing in the lounge of Queen's Cottage – that he will write a novel called *The Circus of Life*. This is, of course, the title of the very novel that we are reading; this kind of thing was very clever and modern in the 1920s.

The completed novel is obviously the work of a very young man. Arkart, when he was in Bexhill, was only eighteen, and his visit to the peaceful town evidently left a deep impression: 'Even though my body is thousands of miles away, my soul remains there forever. Never shall I forget the Queen's Cottage.' If the novel is anything to go by, Arkart's stay on the coast was a rare time of peace in an unruly life, a life which ended with his suicide in a Hong Kong hotel, aged just twenty-six.

Minnie Pallister and the Old Town

No. 4 High Street was the site of Bexhill's first bank. Afterwards it became a surgery for the practice of Savill, Stokes, Lishman, Gardner & Dunnill. The pharmacist was called Gladys and in the 1930s she lived above the surgery. She had a sister called Minnie who was an energetic socialist, feminist and pacifist. Minnie had taught at an elementary school in Brynmawr and was ILP organiser for South Wales. She was by all accounts an electrifying speaker and was well known to readers of the *Daily Herald* and to Labour party supporters up and down the country. She was not afraid to present feminists truths to working-class men. Minnie was expected to be a Labour candidate for Parliament, but her health broke down. Her doctor advised her to live as a cabbage and so – perhaps unflatteringly – she came to live in Bexhill. She and Gladys – whom Minnie called 'Podge' – lived in the Old Town for years to come.

While living in Bexhill, Minnie continued to write, and later she became a broadcaster, with regular appearances on *Woman's Hour*. At some point in her career – perhaps it was in Bexhill, or in the corridors of the BBC, or perhaps she was simply a well-known voice – she came to the attention of Spike Milligan. When *The Goon Show* was broadcast, one of the regular characters was a lady called Minnie Bannister. In one early outing she is the first victim in a 1954 *Goon Show* episode called 'The Dreaded Batter-Pudding Hurler of Bexhill-on-Sea'.

When Minnie first came to Bexhill, she wrote a book about her experience: *A Cabbage for a Year*. This describes how she and Podge created a home and garden for themselves,

Minnie Pallister. (Independent
Labour Party)

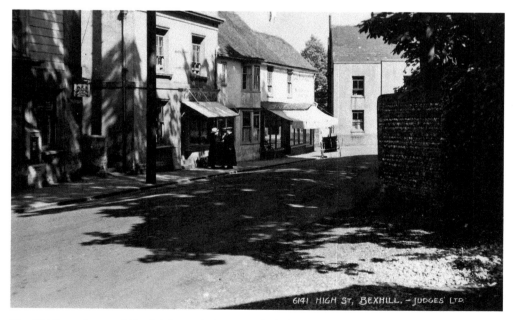

The Old Town in 1931. Minnie's house is just past the ladies talking.

aided by a local gardener Mr Honeysett. She describes how the Old Town – then as now – is a world away from Bexhill's seafront. As she walks north from the station, she steps as if by magic from her own century to her grandmother's. The seaside resort that she describes is, by contrast, rather like many other resorts, with 'bathing huts, girls in every sort of weird pyjama suit, hotels, picture-postcard shops...' Parts of the new seaside town, however, are still fairly upmarket: 'exclusive little shops, "home-made" cafes, "arty" shops full of hand-made beads and pottery, expensive florists...'3

Agatha Christie

A café/tearoom of the 'home-made' kind features in Agatha Christie's 1936 detective novel *The A.B.C. Murders*. A murder victim, Bettie Barnard, works at the Ginger Cat café in Bexhill. The fictional café is located on the seafront and is unexceptional. The tables have orange-covered checked cloths, and the chairs are fashionably uncomfortable, made of basketwork and with orange cushions. The café sells five different types of afternoon teas, including Devonshire and Fruit; it also offers some light lunches for its female clientele, including macaroni au gratin. The owner wears lots of fichus and frills as part of her uniform. Bexhill had many of these home-made cafés. In real life, the Village Tea Rooms in Old Town offered a range of home-made pies, cakes and preserves; sometimes there was even home-made tangerine marmalade. The Rolling Pin at No. 59 Sackville Road offered cakes and jams and also offered healthy and dietary foods.

In *The ABC Murders*, Betty Barnard is a twenty-three-year-old waitress and is dead before we meet her. *The Daily Express* serialisation showed her body lying on the eastern beach near Galley Hill. The sleuth Hercule Poirot comes down to the coast to investigate. He has recently been to Andover to investigate the murder of Alice Ascher. Now Bettie Barnard of Bexhill is dead. The killer is alphabetically inclined, and things do not look good for Carmichael Clarke in Churt.

DID YOU KNOW?
In 1930 the town tried to find a poster design that would help advertise it as a holiday location. The railway companies had failed to produce a convincing design. A poster for Aberystwyth was especially admired, but it was feared that Bexhill did not have the striking natural attractions needed for a good poster.

Agatha Christie's daughter Rosalind joined the Caledonian School at Cooden Beach in 1928, at the age of nine. Agatha Christie had a sharp eye for contemporary detail, and knew something about Bexhill. Bettie's body was discovered on the beach by a 'fresh air, early-morning colonel' out walking his dog. This retired colonel was a perfect representative of the early wave of Bexhill retirees, but Bettie was not from the retired-colonel class. Bettie, the murder victim, was a young flirt who worked as a regular waitress in the café and her sister Megan works as a typist. The two girls, incidentally,

go to Hastings to use the swimming pool, since Bexhill does not have one. Megan has 'a mass of rather frizzy curls', with high cheek bones; her whole figure has 'a queer modern angularity'. Poirot judges that her face was certainly not beautiful 'but had an obvious and cheap prettiness'. She smokes cigarettes and sits on the edge of the table. The twentieth century, independent-minded, modern and slightly cheap, has come to Bexhill.

Bettie's father is in his fifties, and is happy for his daughters to lead independent lives. Bettie lived at home but did not have her own door key, which was left under the mat outside the house. The father – we only know him as Mr Barnard, and his wife calls him 'Dad' – used to run an ironmongery business in Kennington. He had always wanted to live by the sea and took the opportunity to come south. He and his wife live in a tiny bungalow with a small neat kitchen. It has a living room, which Mr Barnard calls a 'snuggery', and Bettie has her own bedroom. They have named their home Llandudno, which reflects the Welsh background of Mrs Barnard. It is a perfect model of the new Bexhill that was coming into existence. Agatha Christie is very precise about the home: 'a minute bungalow, one of fifty or so run up by a speculative builder on the confines of the town.'4

Bungalows

We could almost move fully from fiction to fact and name the builder of the Barnards' bungalow: R. A. Larkin. Before the First World War, the seafront and the Old Town were two separate settlements. After the war, the intervening space was filled by a program of residential housebuilding. At the heart of this was Mr Larkin, helped over time by his brothers and a permanent staff of 120.

Reginald Larkin started his working life as a plumber in London and went to evening classes to become a draughtsman; it was as a draughtsman that he then joined the Royal Naval Air Service. After the First World War he came to Bexhill because he liked the area, and set up as a builder. He built his first bungalow in Plemont Gardens and before long was able to build a whole road of houses at Leasingham Gardens. Work was patchy at this point, partly because of changes in government spending policy. Larkin's brother Jack was made redundant as a chemist, and he came to join the building firm in Bexhill. The Larkin business had suffered from fluctuations in the market for builders, so the emphasis moved to speculative house-building. This allowed Larkin to keep a steady core of workers in employment, even when there was no immediate market for his work. The company grew to 120 full-time employees and many subcontractors. He kept his own stock, and was able to make economies by bulk purchases. In 1933 headquarters moved to Woodsgate Place, a large house in Woodsgate Park. In the mid-1930s, Larkin published some very forward-thinking brochures to sell his houses, showing aerial photographs of the countryside between the Old Town and the seaside. These aerial photographs had the new roads drawn in, showing the map of Bexhill as it was soon to be. The accompanying text offered a bucolic vision: 'At present cattle roam in rich pasture and graze in the shade of trees planted to border the road.'5 Once the developments had been completed, of course, the cows would be gone and their pastures would be under tarmac.

Larkin built some very high-spec new homes in Cooden, houses that were widely believed to be unsellable but which have since proved to be the some of the most valuable

Mr Larkin's bungalows.

in the town. The bulk of the business, however, was at the lower end of the market. The Larkins could offer a simple process for buyers, offering a fixed price to include moving costs and legal fees. At Bancroft Road the new buyer could have a standard bungalow for £25 cash and 14s 4d thereafter, or a total freehold cost of £505. There was also a slightly more expensive version with bow windows. Larkin took on a larger project when he built Newlands Avenue, where he provided not only houses but the road and the sewers.

During the Second World War the firm had only eighteen permanent employees, providing pillboxes, maintaining military billets and dismantling bomb-damaged houses. In the post-war period, when building was strictly controlled, the Larkin firm-built council housing then returned to its old role. By 1970, according to R. A. Larkin, the firm had built 2,000 houses in Bexhill and housed 20 per cent of the town's population.

The Mysterious Cobbler

At No. 16 Station Road there was a cobbler's shop. The cobbler was Arthur Spray and he was known locally as a healer. He was born in 1889 in Sidley, at the Black House in Spray's Cottages. He developed a knack of curing aches and illnesses by the laying on of hands. He was able to persuade an insomniac at the gasworks that he had had a good night's sleep, and he could cure serious maladies. Stroking one patient's head, he found that uric acid crystals had formed on his hands. He was the subject of a 1935 book, *The Mysterious Cobbler*. The woman who prepared the typescript for the book alerted her mother, who had been paralysed for ten years, The mother visited Arthur and was cured.

ARTHUR SPRAY, COBBLER

The Mysterious Cobbler. (Bexhill Museum)

The bootmaker's shop in Station Road was visited, Arthur tells us, by millionaires, doctors and titled folk.

Arthur Spray had a theory for what was going on. God, he decided, was like a huge broadcasting station. Hypnotism – another of Mr Spray's skills – was rather like a radio set receiving a message from the ether. He offered advice on influencing other people: 'The next time you have a visitor you want to get rid of ... fix your eyes on the bridge of his nose, or better still on the back of his neck, and make yourself see a picture of him getting up and going out the door.'[6] Spray was interviewed by the *Sunday Despatch*, whose reporter was impressed by his work. Spray was especially convincing when he had his assistant whom the *Sunday Despatch* called Alice (possibly her real name was Daisy). She was a mediumistic hypnotic subject. At the *Sunday Despatch*'s office, on 3 January 1935, she could, while in a trance, see a man hanging by his thumbs from the corner of the room. She offered to help the police with their enquiries: Spray explains that at one point she travelled mentally to Australia to help with some lost money. Spray had his bootmaker's shop in Station Road, but later ran a practice from his house at No. 33 Salisbury Road. He described himself as an osteopath. Another osteopath in Bexhill was Dudley Langham Smith, a nature healer who attempted to cure himself by fasting and starved to death in 1934.

Salisbury Road, where the Mysterious Cobbler had his practice.

The Schools

Bexhill's major industry in the twentieth century was private education. Its reputation as a quiet and respectable town, with plenty of fresh sea air, made it a perfect spot for middle-class residential schools. During the century over 400 schools were established here. Sadly, not one of them achieved national fame. Harewood School in Collington Avenue educated the young Reginald Maudling (1917–79), who had a mixed career as a politician and acquired a reputation for sleaze long before that term became common. On the positive side, as Chancellor of the Exchequer he legalised home brewing of beer. The Winceby House School was set up by two sisters in 1915, and produced Dame Wendy Hillier (1912–2003). Dame Wendy was sent to Bexhill in the hope that she would lose the northern accent inherited from her cotton-manufacturing father. She went on to win an Oscar for best actress. For the most part, however, the schools of Bexhill seem to have inculcated a modest acclimatisation to middle-class life. There were, however, two remarkable exceptions.

The first of these was the Bexhill School of Music at No. 15 De La Warr Road. This was the creation of Helene Gipps, a Swiss woman who had married Bryan Gipps. She often styled herself Mrs Bryan Gipps but was in every way the head of the household and of the school. Bryan had attempted to set up businesses to allow her to pursue her musical studies, but he was not a success. Helene therefore set up a music school, which was the family's main source of income. In February 1921 the couple had a daughter christened

Home of the Bexhill School of Music.

Ruth, but known as Widdy. In 1925 the daughter demonstrated an astonishing ability at the piano, reproducing music by ear. In 1926 she gave her first public performance in London, and by 1929 she had published her first musical composition. After an injury to her hand she turned her attention to composing and conducting. Women were not usually chosen as conductors, but characteristically she set up her own orchestra. Her music is not performed much at present but that may well change.

Just over the road from the School of Music was another remarkable institution: the Augusta Victoria College at No. 82 Dorset Road. On 20 April 1939 the girls had a special treat in store. Dinner was much better than usual, and the headmistress ran up a large swastika flag. It was the fuhrer's birthday, and the school celebrated in style. As well as the good dinner, there was a chance to sing some rousing Nazi songs. This was not an aberration. As early as May 1937, *The Times* of London shows girls from the school greeting the German ambassador with Hitler salutes. In the evenings, the girls would listen to radio broadcasts from Berlin.

The school had good relations with Berlin; in fact, because of currency restrictions, the school could not have survived without some well-placed German friends. The headmistress was a Frau Lochol, who taught cookery and German values. She was assisted by the Baroness von Korff. The schoolgirls included the daughter of Joachim von Ribbentrop, the German foreign minister and supposed lover of Wallis Simpson. A girl called Mollie Hickie worked there as an au pair and recalls that Bettina Von Ribbentrop was not a nice person. She was an enthusiastic Nazi and 'everyone was a bit on their toes,

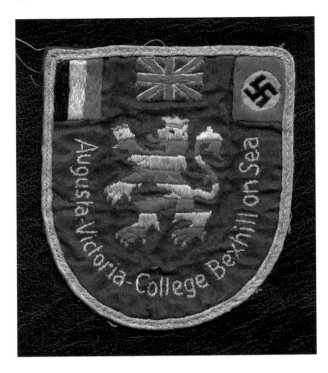

Probably the only English
school badge with a swastika.
(Bexhill Museum)

in case they said the wrong thing'.7 Millie, sadly, has no recollection of Von Ribbentrop coming to the school. This casts a doubt on the old legend that he stayed at the Cooden Beach Hotel when he came to visit Bettina.

When not singing or listening to the radio, the school was mainly focussed upon the Cambridge Certificate of Proficiency in English, although it taught other subjects as well. English girls could study there, and were offered reduced fees if they could provide conversation lessons. The school was the subject for a 2019 feature film starring Judi Dench and Eddie Izzard.

In real life there was an intense political drama associated with the school. Among the schoolgirls was sixteen-year-old Reinhild Hardenberg. She came from a strict Prussian aristocratic family, and was embarrassed by her old-fashioned 'Teutonic' plaited hair, which her Juncker father insisted on. She attended Augusta Victoria in 1939, but had to head home when war threatened.

Reinhild came from a conservative background. Her father, Count Carl Hans von Hardenberg, was an eminent German soldier who was vehemently opposed to the Nazis. Reinhild became engaged to Lieutenant Werner von Haeften, an aide to Colonel Stauffenberg, and a member of the July 1944 plot to kill Hitler. When the plot failed, Werner was shot immediately. Reinhild was arrested by the Gestapo and she was very lucky to be released five months later. Her father attempted to commit suicide but failed. He was kept in Sachsenhausen concentration camp and was due to be tried and executed, but fortunately the camp was liberated the day before he was due to be sentenced.

10. The Pavilion

At Bexhill station today we see the logo of Bexhill College, three stylized wavy lines stacked one above the other. For people in Bexhill, the meaning is obvious. This is the De La Warr Pavilion, a highly functional modernist building. It is one of the best-known modernist buildings in England, and is Bexhill's icon. It has not always been popular, certainly not among the ratepayers of Bexhill. According to Spike Milligan, resident in Bexhill for two years during the Second World War, it is 'a fine modern building with absolutely no architectural merit at all'.[1]

It is certainly a fine modern building. The architects Erich Mendelssohn and Serge Chermayeff were masters of detail. The frame was intended to be wholly of welded steel and the tiles were from Poole Pottery. Mendelssohn understood building techniques. A few years later his full-scale replicas of Berlin apartment blocks – commissioned by the US Air Force to test their bombs – were considered vastly more precise that the similar imitations built, for the same purpose, by the Royal Air Force. Tiny details mattered to the architects. The building still sits uneasily on the seafront, but the style is now all too familiar. This could be a 1970s college building or any company's regional headquarters but in 1936 it was revolutionary.

It was the brainchild of Herbrand De La Warr (1900–1976), the 9th Earl. He was perhaps disingenuous about his aims. In April 1933 the council – of which he was currently mayor – agreed to spend £50,000 building an entertainments hall on the site of the old coastguard station. The mayor explained that it was essential to let the whole town know what was being proposed and that the whole town had to be carried along with the project. Bexhill, he explained, had had a period of rapid development followed by a period of consolidation. Now was the time for more development. It had to be done carefully, because people liked the quiet that Bexhill offered. He promised that he would be 'developing according to the traditions of our town'.[2] There had been hopes that the site could be developed in conjunction with a private company, but under De La Warr's leadership, the council opted for a wholly public enterprise. The ratepayers were uneasy, and within a few months the £50,000 budget had been extended to conditionally include another £10,000. The mayor thought that this would be money well spent. Currently the town was spending £3,000 on entertainments, using an unsuitable venue. In a suitable venue, that money would be much better spent, and yield more revenue for the council. There was no detailed quantification of this hope.

Herbrand was at this time a member of the National Government, but his political life had started much earlier. When his father died in 1915, he was only fifteen. At the age of eighteen he joined the navy. At the time this was portrayed as a good patriotic move. The Marquess of Lincolnshire describes a good-looking young boy who turned up at the House of Lords in the uniform of an able seaman. He introduced himself as De La Warr.

The Pavilion today.

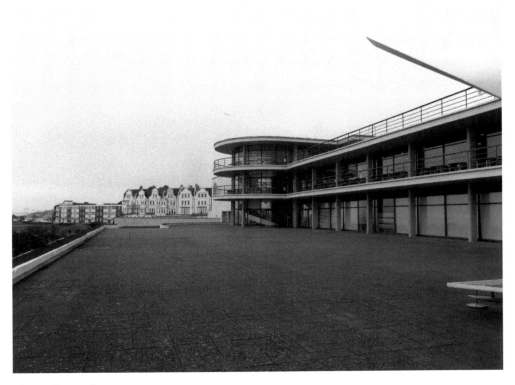

The Pavilion today.

After a short time in the building he returned to his ship 'to do his duty to King and Country. That is the kind of men we breed in this country, and whom we send to fight for the small nationalities of the world, to keep the flag flying and protect civil and religious liberty all over the world'.3 What the marquess did not say – and presumably did not know – was that Herbrand was a conscientious objector.

Herbrand had joined the Royal Naval Reserve in a non-combatant role. In 1924 he became the first hereditary peer to sit in the House of Lords as a Labour Party supporter. Ramsay MacDonald brought him into the Labour government soon after. Herbrand remained loyal to MacDonald through the turbulent years that followed, even when the Labour Party split away from him. (In 1924 Macdonald had just renewed a passionate affair with a woman fifteen years younger than himself: Lady Margaret Sackville, Herbrand's aunt.)

Herbrand was a significant political figure in the 1930s, but retained his commitment to Bexhill. He was a socialist, and this was a time when socialists liked shiny modern buildings. Minnie Pallister had gone on record saying that petrol stations could be finer buildings than garden city cottages. W. H. Auden was calling for 'new styles of architecture' and Herbrand was determined to answer that call. The tender for the building made it quite plain that only a truly modernist approach would win. The resulting building met with the high standards of George Bernard Shaw, whose play *The Millionairess* had its first night in the Pavilion. The Pavilion itself, with its reference library and its proposed heated swimming pool, was not only an entertainments centre: it was meant to lift the

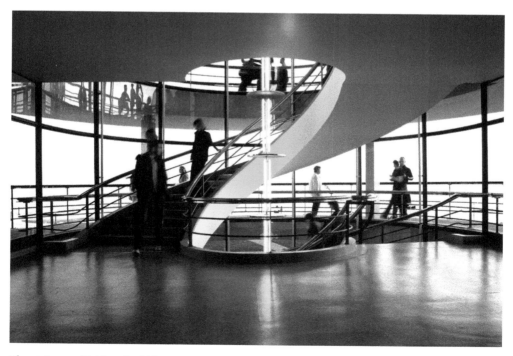

The staircase. (Bridget Smith)

standards of Bexhill's people. There was, ironically, an accusation of class distinction very early on. A working men's club, which wanted to hire the hall, was being charged fifteen guineas while the Bexhill Traders were only being charged twelve guineas.

The full plan for the entertainments centre was never realised. There was to have been a giant statue of Persephone, sculpted by Frank Dobson, as well as a swimming pool. The statue was regarded as central to the whole complex. One irate Bexhillian wrote to the paper that the statue was needed to stop the Pavilion being 'another eyesore on the Sea Front'.4

The entertainments building did make it through to completion, even if the larger plans were shelved. The Duke and Duchess of York (soon to be King George and Queen Elizabeth) came down to Bexhill. They had lunch at the Cooden Beach Hotel and moved to the town centre for the official opening. This gave the socialist enterprise an element of royal backing, which was to prove decisive a few decades later.

Bexhill already had two pavilions, and it was thought, by some at least, that the new building might be called Marina Hall. There was a concern that unless a name was found, someone would invent a joke name that would stick. In June 1935 the council decided unanimously that the entertainments centres would be called the De La Warr Pavilion. This was mainly to reflect the mayor's tireless work on the project, but also to give it a distinctive name that would stand out for publicity reasons.

DID YOU KNOW?
Newspaper letters from the 1930s show that the locals did know how to pronounce De La Warr. They had pronounced it 'De La Waw' or 'De La Wahr' or, with a Scottish sound, 'De La Warrr'. Then, we are told, they heard Muriel on the wireless pronouncing her name as 'De La Ware'.

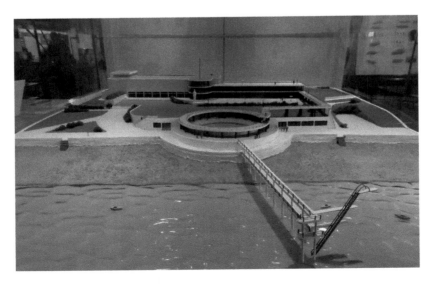

The architect's
model.
(Bexhill Museum)

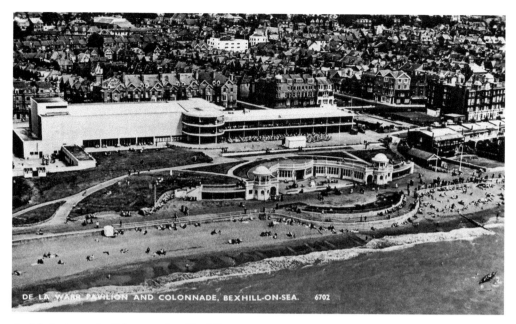

Aerial photograph of the completed building.

Not all residents had their views enhanced by the Pavilion.

The building was in the international style and was intended to be beautiful through functionality. In fact, the most famous part of the Pavilion is a circular stairwell, which graces the side of the building like a side tower on an imitation French chateau. This is the feature that gives the local college its logo. Where local buildings have an homage to the Pavilion, they have just such a stairwell.

Although the building was intended as functional, it failed in its prime function, which was to bring money into the town. The reference library and the concert hall were excellent, but the improving ambitions of the earl were to prove expensive. The original tender seems not to have fully included many essential elements of an entertainments centre: office space and storage space were in short supply and over the years the building was modified to graft these onto or into the building. By the 1970s the building was covered in ivy and the interior had lowered ceilings and flock wallpaper. There are stories, probably apocryphal, of the council wishing to add mock-Tudor timbers to the outside. In the 1980s the Pavilion was very nearly sold to Wetherspoons.

Such a building brought a heavy cost of ownership, and the building fell into disrepair. However, the building had its supporters including the Queen Mother. A Lottery Heritage grant later, the building is now restored to something close to the architect's modern dream.

In the 1930s no one expected this kind of struggle. Modern buildings were on the way including Motcombe Court, an art-deco block designed by Henry Tanner.

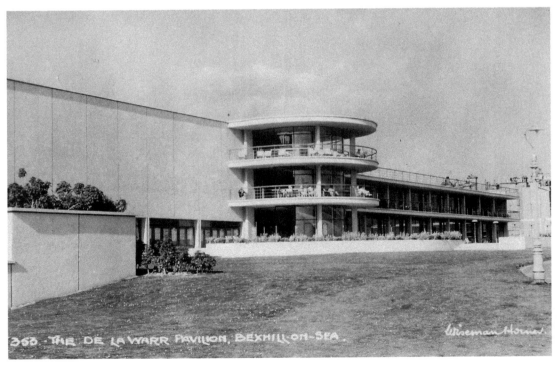

The Pavilion after construction.

Recent building in the town centre.

Recent buildings near the Old Town.

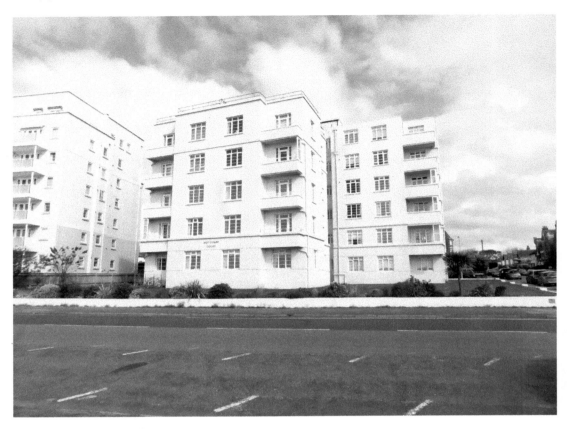

Motcombe Court today.

11. The War

In February 1940 Springfield Road Methodist Church saw a meeting that would have been scarcely possible in any other combatant country. Minnie Pallister, still living in the Old Town, was in the chair, and the main speaker was Dr Maude Royden. The subject of the meeting was 'the peace we want', and Dr Royden explained that her own family had men in the services and had lost young men in the previous war. Dr Royden was moving slowly towards the idea that Britain should fight the war for progressive reasons, but she had clearly not yet reached this destination. Britain, with its large, racially exclusive empire, was being hypocritical in criticising others, she felt. The important thing now was to get the beam out of our own eye before examining the mote in our enemy's eye. This was all true, but did not deal with the more pressing question of what was brewing across the Channel. Dr Royden seems to have been sanguine on this matter: she felt that Hitler would respond positively to public opinion in the civilised world. At home, however, there was the problem of Winston Churchill, the First Lord of the Admiralty.

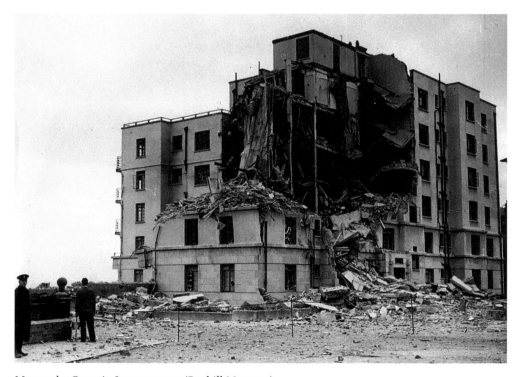

Motcombe Court in January 1943. (Bexhill Museum)

He had been making 'violent' speeches, and was even being allowed to broadcast on the BBC. Dr Royden advised that people in the audience should write letters of complaint to the national broadcaster, as allowing Churchill to speak on the BBC 'was doing nothing but harm'.[1]

To begin with, Bexhill was a place that received evacuees. The Augusta Victoria College was taken over as a convalescent home, but seems to have been used for housing difficult children. In November 1939, one girl evacuee who had been untidy and a continual nuisance was sent to the college. In 1940 there was a complaint about a boy who had filthy habits and had his fingers in everything. The host parents were willing to keep his sister, but would not tolerate him in the house. He too went to the Augusta Victoria College.

DID YOU KNOW?
In 1973, the comedian Spike Milligan was surprised at the De La Warr Pavilion by TV compere Eamonn Andrews. Andrews was carrying a red folder, the material for a *This Is Your Life* TV biography. It was not the first time that Milligan had been at the Pavilion. During the Second World War he had been stationed inside the Pavilion for nine months.

This was the time when – in the famous introduction to the TV program *Dad's Army* – a tentative little broad arrow, emblazoned with the Union Jack, was pointing its way into northern France. By the summer of 1940, the British arrow had retreated back to Blighty and the black Nazi arrows had come to halt at the Channel ports. German war plans for 1940 show a very thick black arrow crossing the Channel and heading to Bexhill. This arrow marks the route of the XXXVII Corps led by Erich von Manstein. Given his appalling record in the Russian campaign, this was a summer visitor that Bexhill did well to avoid.

With the arrows pointing at Bexhill, evacuation went onto reverse. From being a safe place away from the Blitz, Bexhill now became a part of the front line and schools were sent away to far parts of the country. Anti-aircraft defences moved from the southern outskirts of London down to the coast, with Bexhill as a key location. Artillery was moved into the town, most memorably the 56 Heavy Regiment of the Royal Artillery, which posted Spike Milligan on D Battery on Galley Hill. After the threat of invasion ended, Bexhill was still a likely target. The town had no strategic value but was in the line of fire. Enemy aircraft passed overhead and might unload their bombs if they had been unsuccessful in approaching London. The V1 flying bombs took a path over Bexhill and could land there by accident or after being hit by fighter aircraft. There were also 'tip-and-run' raids delivered by the 10/JG26 group, headquartered in Abbeville in Normandy, like the one on 2 January 1943. Four FW 190s took off from France at 08.38 and reached Bexhill at 09.00. Four general purpose SC500 bombs were dropped onto a large housing block, resulting in a yellow-grey explosion and heavy smoke.[2] The housing block in question was Motcombe Court.

An air-raid shelter on Sea Road.

The moat, which was used as a dump for Second World War tank traps.

Altogether, Bexhill experienced fifty-one air raids, which killed twenty-two people and destroyed seventy-four building. The numbers of the people wounded and the buildings damaged was, of course, much higher. In 1944, the town was introduced to the German V1 flying bomb, an early cruise missile. These were launched from the northern French coast and Bexhill was in their flight path. On one day in 1944 more than forty of them flew over the town on their way to London. Anti-aircraft guns were moved south, equipped with new predictive aiming systems. V1s crashed on the town, but fortunately killing no one. One of the resulting craters is still visible on the Mount.

The war memorial.

12. The Grey Haven: Retiring to the Seaside

It is sometimes said that people retire to Eastbourne to live by the sea but they retire to Bexhill to die by the sea. Bexhill certainly has some well-known inhabitants who did little in the town apart from die. The Maharajah of Cooch Behar came to Bexhill when he was ill and died soon after. Most famously, Logie Baird came to the town in 1945, renting a house at No. 1 Station Road. He was not well and wanted to experience the dry air of the south coast. He died in June 1946, best known for an early form of TV. He is remembered in the name of Baird Court, built on the site of his Bexhill house. Fanny Cradock, who came a little later to Bexhill, was famous as a TV cook, but it is not clear that any of her recipes have survived into the modern world. Her recipes were colourful, in a very literal sense, with her green cheese ice cream looking especially vibrant. The bigamist Fanny and her husband Johnnie lived out their days at No. 95 Cooden Drive.

An ideal of Bexhill. (Raouf Oderuth)

Left: Commemorative benches at Galley Hill.

Below: Commemorative Benches at the Manor Gardens.

Major Eric A. Sykes (not to be confused with the comedian Eric Sykes) arrived in Bexhill in April 1945. He had left the army on health grounds and checked into a boarding house in the town. On 12 May 1945 he died. Major Sykes' invention had many users and was in its own way a classic of modern design. Sykes had worked for many years in the violent world of the Shanghai police, then moved back to Britain in 1940. He was the co-author of *Shooting to Live*, a handbook of pistol combat, and was an instructor in unarmed and knife fighting. He became a trainer for the Special Operations Executive and in this cloak-and-dagger world, he supplied the dagger. The Sykes-Fairbairn fighting-knife was a double-edged stiletto, with a blade long enough to pierce a soldier's winter greatcoat. It was issued to Commandoes and SOE operatives, and was still being issued forty years later, for the Falklands conflict. On the subject of the Secret Service we could note that Desmond Llewellyn, who lived at Linkwell in the High Street, played the gizmo-creator 'Q' in seventeen James Bond films.

Most retirees did not come to Bexhill to die; they came to live for many contented years in a clean and healthy coastal resort. In the post-war years, the town became a retirement complex. At this time, 95 per cent of Larkin's sales were to Londoners, frequently moving to retire. According to Eddie Izzard, hordes of retired people came 'and they just slowed everything down'.[1]

In 1901, 6.3 per cent of Bexhill's population was of retirement age, compared with 6.1 per cent nationally. By 1971, 16.1 per cent of the nation's population was of retirement age but the figure for Bexhill was 44.4 per cent. Almost half of the town consisted of retired folk. They had made a positive decision to come to the town. For a third of the people who moved to Bexhill, the clean air and better climate was the main attraction. Bexhill's motto of '*Sol et Salubritas*' ('Sun and Health') was holding good. For another 16 per cent, the attraction was the quiet the town offered. For the most part they were better off than other retired people. Most of the new retirees described themselves as professional or managerial. Only 2 per cent said they were semi-skilled or unskilled. Many of these newcomers were still active, so that clubs and societies were well supported.[2]

There were flickers of controversy. Bexhill acquired another pacifist when the Revd R. S. Waterson arrived at St Augustine's Church in Cooden. This church was originally set up because of the number of schools in the area. When it featured on the BBC radio's Evening Service in May 1954, the readings came from the senior girls of the Winceby School. The music included 'Glorious Things of Thee are Spoken' and 'Fight the Good Fight'. The vicar had once, however, had a moment of international fame, featuring in the *New York Times*. Far away, on the coast of Colombia, a local journalist Gabriel Garcia Marquez picked up the story. The Revd Waterson, he tells us, was disturbed in 1950 by the invention of the hydrogen bomb. He decided that the British government should call an international conference, to include the Russians and the Americans, to ban the new weapon. Not content with that, he announced that he was going on a fast to promote the cause. It was not quite a hunger strike as the reverend would only fast during Lent, and the fast would be limited to twelve hours a day. The day would begin with a boiled egg (it is not clear if toast was included) and finish with a ham sandwich. Prime Minister Attlee responded that he was not willing to call the conference. The fact that he responded at all is remarkable.

82

DID YOU KNOW?
Desmond Llewellyn, the Welsh actor, lived in the Old Town. He had a long career
as an actor, but was best known for his role as Q in the James Bond films, including
From Russia With Love in 1963.

To maintain its political balance, Bexhill was also host for a short time to Herr Heinz
Linge, Hitler's valet and bodyguard who, after his release by the Russians, went on a tour
of Britain, appearing on TV programs.

Coming of Age in Bexhill

Perhaps there is a general rule that towns designed for retired people do not have happy
youngsters. A more specific rule seems to be that a dull and conservative old population
will breed radical sentiments in the few young people about. One of Bexhill's most
distinguished sons is the playwright Sir David Hare. He has had a long career in theatre,
from his first play *Slag* in 1970 to *I'm Not Running* in 2018. On television he wrote for
award-winning *Licking Hitler*. His works include the play *Plenty*, which was adapted into
a film starring Meryl Streep. He also wrote the film script for *The Hours*, where Nicole
Kidman played Virginia Woolf. It is an impressive record, but the celebrated leftist Hare
seems to have left little mark on the town.

Hare was born in St Leonards in 1947 but in 1952 his family moved to Bexhill. More
precisely they moved to the semi-detached house at No. 34 Newlands Avenue. It is the
kind of house that makes estate agents sleep comfortably at night: sturdily built in a

Newlands Avenue, designed by Mr Larkin.

wide and leafy street. At the top of the road – the posher end – there are detached houses and St Stephen's Church. Just around the corner there is a large park. It is, in fact, one of R. A. Larkin's first attempts at environment building. He built the road and the sewers of Newlands Avenue, and designed each house. The architect's plans for semi-detached houses at Nos 32 and 34 are still preserved at the East Sussex Records Office. They show the 1930s dream of suburban living, in rich brown brick with leaded windows – a perfect ladybird-land residence.

David Hare hated it. It was a street in which 'everyone lived in houses constructed by the same local builder.'3 It was a post-war world where people tried to recover from the psychological ravages of war by a numbing respectability. 'How do I begin to explain the level of repression obtaining in Newlands Avenue?' asks Hare. It was a world where washing could not be hung out on a Sunday. At the adjoining house, No. 32, the neighbours set the breakfast table as soon as they had cleared up the dinner plates – breakfast included marmalade jars with frilly hats. These next-door neighbours were the Yearwood family, and the Hares looked up to them. A little further down the road were the Richfords. Living as they did in a bungalow and having no car, the Hares looked down on them. A risqué move was to visit the Cosy Café in Sea Road to eat a Wagon Wheel chocolate and marshmallow bar.

David Hare. (Iona Wolff)

Indoor bowls and traditional carpet gardening.

Seaside shelter on the promenade at Bexhill.

Perhaps the town would rather not be reminded of Hare's final judgement:

It's a wonderful fortune for a writer to be born somewhere boring, In the 1950's, Bexhill and boredom were joined at the hip. Tedium is hugely stimulating for a child's imagination. Suburbia is a classic writer's breeding ground. For the rest of your life, everywhere you go is intensely interesting, because it's not Bexhill.[4]

Along the Coast – Pevensey Bay

Much of Bexhill reflects the conservative tastes of a single local builder. The classic Larkin building is in brown brick with perhaps leaded windows and some Tudor gabling. This fits in with the character of interwar Bexhill. It is worth comparing with what was happening just along the coast. Bexhill ends at the small hamlet of Normans Bay. Moving just a few hundred yards west of the boundary, we see a different type of bungalow. In the 1930s, Pevensey Bay saw an expansion of modernist housing including the 'oyster' bungalows.

The early development of the bay was under the influence of Val Prinsep, the Victorian artist, and his son Nicholas had an imposing modernist home built at the edge of the sea. It is now in classic modernist white but in its day was known as the Pink House.

The Beachlands estate was a focus for modern sun worshippers, and was intended to have a substantial sports complex. The ethos of the bay was highly unconventional; for example, just thirty years after Bexhill allowed mixed bathing, Pevensey was allowing nudism. This upset some of the residents but the local traders were very happy.

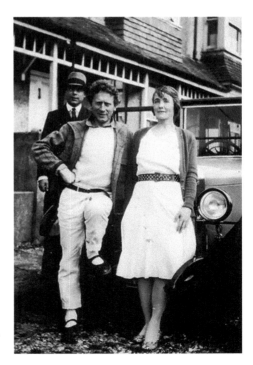

Ella and Percy Grainger at their home in Pevensey Bay. (Percy Grainger Estate)

Left: A modernist home on the beach at Pevensey Bay.

Below: Oyster bungalows.

1930s modernism at Beachlands.

Swedish-style bungalows.

The general ambience was what people thought of as Scandinavian and Beachlands later acquired a set of 'Swedish Bungalows'. One of the more interesting inhabitants was a Swedish woman called Ella Ström. She lived – unmarried but with a daughter – in a small house in the bay. She was known as a potter and poet, but seems to have lived courtesy of her lovers. In 1928 she married Percy Grainger, who had frequently come to Pevensey to visit her. Their lives together are documented in remarkable detail in Grainger's autobiographical writings and would have been classified at the time as distinctively 'modern'.

In the post-war period, when Spike Milligan and his fellow Goons came to the south coast for their weekends away from London, they made their way to the Beachlands estate rather than Milligan's old haunts in Bexhill. In the 1930s, and in the 1950s, Bexhill chose to be a conservative town.

Bexhill in the 1970s

Eddie Izzard seems to have had as little fun as David Hare. Eddie is in many ways a classic Bexhill child, born in an Imperial outpost and educated in Sussex. His father was working as a cost accountant in Aden when Eddie was born. The family moved back to Bexhill in

1969 and Eddie grew up at No. 74 Cranston Avenue. In his youth he cycled around Bexhill, looking for the places that Spike Milligan knew. Eddie worked at an ice-cream parlour and sold egg and chips at the De La Warr Pavilion. His childhood railway set is on display at the museum. Being young in Bexhill was not fun. Eddie has worked hard to make things happen in Bexhill, paying £70,000 for the Richard Wilson *Hanging Bus* sculpture to be placed on the pavilion roof. He is best known, of course, as a transgender comedian and leftist political activist. When he was young he said 'the amusement arcade was the only thing going'.5

Eddie Izzard at the Pavilion. (Bexhill Museum)

Cranston Avenue.

13. The Western Approaches

The western parts of Bexhill, less densely populated than the main town, have had their own history. To the north-west, the borough seems happy to have lost a part of its territory. Back in the glory days of civic pride in 1902, the borough commissioned carved boundary stones to demarcate its boundaries. Some of these are still standing. The one near the Barnhorn Road at Northeye is especially difficult to locate as it is hidden next to a footbridge bridge, deep in foliage. It is mysteriously half a mile west of the faded sign that welcomes us to Bexhill. Between the old boundary stone and the new sign there is an empty field. A few years ago, this was the site of Her Majesty's Prison Northeye. It was famous in its time for a prisoners' strike (in 1972) and a very large riot in 1986, which destroyed most of the prison. Possibly the borough was happy to have motorist safely past the prison before they were welcomed to Bexhill.

Further south is Little Common, which once had a village pond, and whose village green was covered over to create a traffic roundabout.[1] The Cooden Beach Hotel was where the 9th Earl had lunch with the Duke of York, and it is one of the De La Warr's success stories. The Cooden Beach Golf Course was used by Ramsay Macdonald, and the houses along the seafront include some of Mr Larkin's best. Successful Londoners have their weekend homes here.

Near Cooden, there have been substantial developments of very similar modern apartment buildings.

A little further west, at the extreme end of Bexhill's territory, is Norman's Bay. This, like Bexhill-on-Sea, was thought to have development potential. There are plans that

190 boundary stone at Barnhorn.

show hotels on the coast but Norman's Bay resisted any such gentrification. 'Informal development' ruled, and on a foggy November evening you could imagine that the days of the coastguard and the smugglers are not over.

Welcome to Bexhill on the A259 at Barnhorn.

The Cooden Beach Hotel.

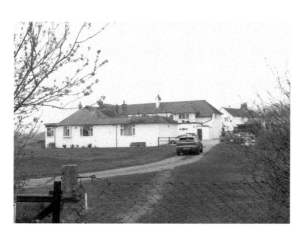

The Cooden Beach Golf Club.

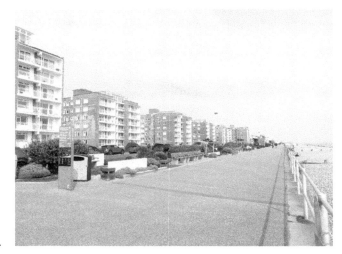

The western end of the seafront.

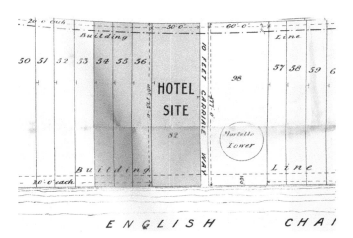

A plan for Normans Bay hotel
before the First World War.

Normans Bay today.

14. Gardens

Through the second half of the twentieth century, the population kept growing, now having over 40,000. This has required house and road building. The planners were not sympathetic to Bexhill's past. The old manor house, a link back through the Sackvilles to the medieval period, was bulldozed. The council had hoped to put a high-rise housing block on this site, but were persuaded to give the space over to the Manor Gardens, which hold remnants of the old building. The gardens are in a traditional style, with different plantings in the different areas demarcated by the manor grounds. The De La Warr Pavilion has now been restored to its modernist grandeur, and the seafront has gardens by the celebrated designer Noel Kingsbury. These show a resourceful approach to the problems of seafront gardens and have been acclaimed – but not always by the locals. When he was planting the gardens, he encountered 'a baying mob'. 'You can't help but feeling that there are a lot of folk here who just dislike any change.'[1]

It is a sentiment that Herbrand De La Warr might have agree with.

Coastal gardens by Noel Kingsbury.

Esplanade by Noel Kingsbury.

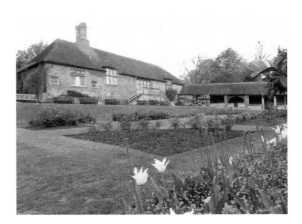

The Manor Gardens.

Bexhill and the sea.

Endnotes

1. Early Days
1. Wills, J. Pearce, *From Bexelei to Bexhill* (Bexhill, 1888)

2. The Hanoverians
1. Lewis, W., *Letters from an Irish Student Vol. 2* (London 1809), p. 56
2. Hardy, Thomas, *The Melancholy Hussar of the German Legion, Wessex Tales* (London, 1889)
3. Ompteda, Christian, *In the Kings German Legion* (London, 1894), p. 176
4. *Cobbett's Political Register*, Volume 34 (London 1819), p. 474
5. Mary Ann Gilbert, *Album of verse compiled by Mary Ann Gilbert and presented to Lord and Lady Ashburnham, 21 Jun 1823* (ESRO ref AMS 6515/1)
6. Shipp, John, *The Military Bijou* (London, 1831), p. 100

3. The Bexhill Coalfield
1. Torrens, H. S., *Coal Hunting at Bexhill 1805–1811* (Sussex Archaeological Collections, Vol. 136, 1999), p. 136–77
2. *The Kentish Gazette*, 31 July 1807, p. 3
3. Leifchild, J., *Our Coal and Our Coal Pits* (London, 1853), p. 91

4. Smugglers
1. Wills, J. Pearce, *From Bexelei to Bexhill* (Bexhill, 1888)
2. Banks, John, *Reminiscences of Smugglers and Smuggling* (London, 1873), p. 54. A book based upon a lecture given at the Hastings Music Hall and dedicated to Thomas Brassey.
3. Shore, Henry, *Smuggling Days and Smuggling Ways* (London, 1847), p. 279
4. Poor Law Commissioners, 'Extracts', p. 24 (London, 1837)

5. Building Bexhill-on-Sea
1. *Bexhill-on-Sea Almanac & Directory* (1892), p. 21
2. Sussex Archaeological Collections (1894), p. 161

6. The Dawn of the Twentieth Century
1. *Bexhill-on-Sea Observer*, 3 June 1905

7. The Aristocrats
1. Quoted in the *Coventry Evening Telegraph*, 12 February 1947
2. Lansbury, George, *The Miracle of Fleet Street* (London 1925), p. 166

8. Adventurers

1. Quoted in Elizabeth Baigent, 'Kate Marsden', *Geographers Biobibliographical Studies*, Vol. 31 (2011), p. 73
2. *Evening Post*, New Zealand, 6 October 1894
3. Quoted in Elizabeth Baigent, 'Kate Marsden', *Geographers Biobibliographical Studies*, Vol. 31 (2011), p. 77
4. Angus Wilson, *The Wild Garden, or Speaking of Writing* (Berkeley, 1953), p. 92
5. Angus Wilson, *The Wild Garden, or Speaking of Writing* (Berkeley, 1953), p. 142–3
6. *The Bexhill Quarterly* (1915), p. 36

9. Between the Wars

1. *Guide to Bexhill* (1937), Introduction
2. Arkartdamkeung Rapheephat, *The Circus of Life,* English edition (Thailand, 1994)
3. Pallister, Minnie, *A Cabbage for a Year* (London, 1934), p. 33
4. Christie, A., *The ABC Murders* (London, 1936)
5. Sales brochure for Larkin Builders, 1935 (ESRO Ref LAR/5/17)
6. Spray, A., *The Mysterious Cobbler* (London, 1935), p. 19
7. Mollie Hicks, interviewed by Eddie Izzard, 2015 (script in Bexhill Museum)

10. The Pavilion

1. Spike Milligan, *Adolf Hitler, My Part in His Downfall* (London, 1971)
2. *Bexhill-on-Sea Observer,* 29 April 1933, p. 7
3. *Bexhill-on Sea Observer*, 23 November 1918
4. *Bexhill-on Sea Observer*, 29 June 1935, p. 9

11. The War

1. *Bexhill-on-Sea Observer*, 24 February 1940
2. Goss, C., and Cornwell, P., *Luftwaffe Fighter-Bombers over Britain* (London, 2010), Appendix 8

12. The Grey Haven

1. *Sussex Life*, 21 March 2015
2. Karn, V. A., *Retiring to the Seaside* (London, 1977)
3. Hare, David, *The Blue Touchpaper* (London, 2015), p. 40
4. *The Guardian*, 17 February 2018, interview with Angela Wintle
5. *Sussex Life*, 21 March 2015

13. The Western Approaches

1. *The Sussex County Magazine,* Vol 21, p. 146

14. Gardens

1. Noels-garden-blogspot 2009/10

Further Reading

Bartley, L. J., *The Story of Bexhill* (London, Hastings and Bexhill, 1971)

Bexhill Hanoverian Study Group, *The King's German Legion* (Bexhill: Bexhill Hanoverian Study Group, 2003)

Gray, Fred, *Bexhill Voices* (Brighton, CCE University of Sussex, 1994)

Guilmant, Alwyn, *Bexhill-on-Sea: A Pictorial History* (London and Chichester, 1982)

Porter, Julian, *Bexhill-on-Sea: A History* (Stroud, 2015)

Porter, Julian, *Bexhill-on-Sea* (Stroud 1998)

Porter, Julian, *Bexhill-on-Sea: The Second Selection* (Stroud, 2002)

Sussex Archaeological Collections

Victoria County History of Sussex

Wills, J. Pearce, *From Bexelei to Bexhill* (Bexhill, 1888)

Websites:

Bexhill Old Town Preservation Society: http://www.bexhilloldtown.org/

Bexhill Open Street Map: http://bexhill-osm.org.uk